NATIVE AMERICAN PORTRAITS

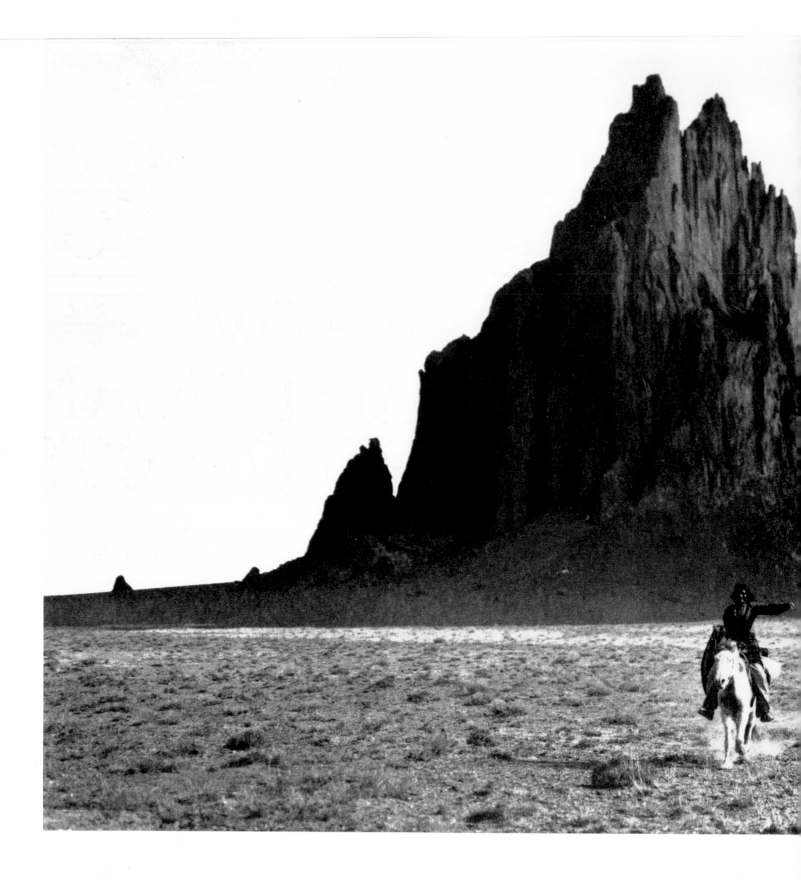

NATIVE $\frac{1862}{1918}$ AMERICAN PORTRAITS

Photographs from
the Collection of Kurt Koegler

Nancy Hathaway

Chronicle Books ▪ San Francisco

Acknowledgments

Many people contribute to the creation of a book and should be thanked, but with this book, one person above all deserves acknowledgment. Kurt Koegler is a New York attorney who began amassing the photographs in this book in 1979. Guided by the eminent photographic curator and dealer Daniel Wolf, he built up an extraordinary collection. A small part of it, approximately a fourth of what is presented in this book, was exhibited at the Milwaukee Art Museum in 1983, and the J. Paul Getty Museum asked to purchase the collection in 1984. Unwilling to give up contact with the people in these pictures, Mr. Koegler declined the offer. Yet he did want to share the photographs with others, and it is out of that desire that this book was born. He has been generous with his resources and his vision.

In addition, I am grateful to Nion McEvoy, Jack Jensen, Annie Barrows, Carolyn Miller, and Karen Pike of Chronicle Books; Peter Palmquist; Richard Buchen of the Southwest Museum in Pasadena; Michael Hargraves of the J. Paul Getty Museum; Gladi Kulp of the Alaska Historical Library; Andy Foley, John Tucci, Sandy Tucci, and Terry Lallman of the firm of Schneider & Company, Inc., in New York City; Bernard and Annie Walsh of Bernard Walsh, Inc.; photographer Sam Ladenson; Mary Goodfader and the staff of Small World Books in Venice, California; attorney Kathryn L. Barrett of Skadden, Arps, Slate, Meagher, and Flom; Judith Dunham; Martin Fox; Louise Gittelson; Diana Rico; Jon Winokur; Gretchen Woelfle; and Sharon Bronte, without whom this book would not exist.

Printed in Japan.
Cover and book design by Karen Pike.
Library of Congress Cataloging in Publication Data.

Hathaway, Nancy
 Native American portraits 1862-1918:
 photographs from the collection of Kurt
 Koegler/by Nancy Hathaway.
 p. cm.
 ISBN 0-87701-766-2.—ISBN 0-87701-757-3 (pbk.)
 1. Indians of North America—Portraits.
 2. Koegler, Kurt—Photograph collections.
 I. Koegler, Kurt. II. Title.
 E89.H38 1990
 779'.2'0973074—dc20 90-38553
 CIP

Distributed in Canada by Raincoast Books,
112 East Third Avenue, Vancouver, B.C., V5T 1C8

10 9 8 7 6 5 4 3 2 1

Chronicle Books
275 Fifth Street
San Francisco, California 94103

INTRODUCTION

Nothing is more intriguing to look at than another human being. Each face is a puzzle of individuality, simultaneously naked and veiled, revealing as much as it hides. Each body, regardless of how it is clothed, commands our attention with its strength and its vulnerability. Photography exploits our fascination by enabling us to scrutinize without restraint.

The pictures of Native Americans in this book are compelling both intrinsically and historically. Photographed between the Civil War and World War One, they include famous chiefs, forgotten warriors, parents and children, babies and centenarians, artists, medicine men, scouts, and many whose names have been lost to us. They all lived during an era of enormous change. Repeatedly forced to relocate to make way for railroads, miners, and homesteaders, they were pushed onto smaller and smaller parcels of land often far from their original homes and ill suited to their manner of livelihood. During their lifetimes, the frontier disappeared, as did the great herds of buffalo; the Indian Wars reached their bloody end; and the traditional Native American way of life, under siege since pre-Colonial times, further disintegrated under an official U.S. policy of forced assimilation. The people who gaze at us from these pages witnessed the attempted destruction of an entire civilization. They lived in a time of despair, contraction, and defeat. During those same years, which for the white population were characterized by a triumphant pursuit of the nineteenth-century goal of "Manifest Destiny," photography was in its ascendancy. The confluence of those events resulted in an extraordinary documentation.

Both in the United States and in Europe, curiosity about Native Americans, particularly regarding their appearance, had always been intense. The artwork attesting to that interest includes sixteenth-century drawings, seventeenth-century portraits, eighteenth-century historical tableaux, nineteenth-century sculpture by Hiram Powers and Horatio Greenough, and paintings by Seth Eastman, George Catlin, and others. The interest was often given official support; Charles Bird King, for instance, was commissioned in 1821 by the first head of the Bureau of Indian Affairs to paint the portraits of a group of Plains Indians who came to Washington, D.C., to confer with President James Monroe.

Many of these artworks, including those intended to be documentary in nature, were heavily influenced by certain stereotyped images. Chief among those images were those of the bloodthirsty barbarian, often caught on the verge of scalping a young blond woman, and the noble savage. The more distant and defeated the Indians became, the more widespread was the image of the noble savage. In literature, it was exemplified by such works as James Fenimore Cooper's 1826 novel, *The Last of the Mohicans,* and Henry Wadsworth Longfellow's poem, "The Song of Hiawatha," which was inspired by a daguerreotype of Minnehaha Falls. Both in literature and in art, the Native American was sometimes viewed as an innocent, ripe for the benefits of civilization (and Christianity), as in a mural commissioned by Congress in 1836 showing Pocahantas bathed in light while being baptized amid a crowd of Indians and English colonists. At other times, the noble savage was presented as a lone and dignified figure, frequently labeled "the last of his race" or "the last of her tribe." These images appeared in public spaces and on parlor walls, for lithographs made from the paintings were immensely popular. They only partially satisfied the curiosity of the white population.

In many ways, photography fulfilled that curiosity. It promised not artistic interpretation but fidelity to the world. Contemporary viewers have seen so much—the embryo inside the womb, the moons of distant planets—that we perhaps imagine only with difficulty the excitement photography first engendered. Yet when the daguerreotype process, which produced an image on a silver-plated piece of copper, was introduced in Paris in 1839, mobs of people thronged in the streets. Photography quickly became a craze, and daguerreotype studios sprang up everywhere. In Europe, pictures of scenery became

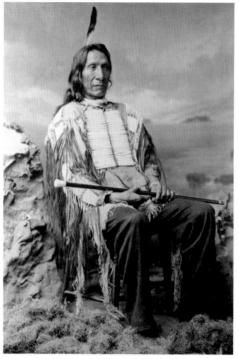

popular. In the United States, where portraits were the preferred mode, daguerreotypists competed with one another to take portraits of adults and children, both living and dead. Native Americans were sought after as subjects of these likenesses. If they were initially mystified by the process, they were hardly alone in that. In 1839, photography was described as a process that "confounds all theories of science in light and optics." Almost a decade later, the popular understanding was hinted at in an advertisement published in Boston by the owners of "the only first premium daguerreotype rooms" (who also guaranteed no "humbug by false pretenses"). The advertisement featured a line drawing of the sun, with a brush in one ray and a palette in another, painting a picture of the world. The Indians had a similar understanding of how images were made. Told that daguerreotypy involved manipulating the light of the sun in order to fix the position of shadows, the Plains Indians described its practitioners as "shadow-catchers."

At first, the Indians were hesitant to have their pictures taken. As their attitude became more accepting, many delegations of American Indians who came to Washington, D.C., to negotiate treaty provisions wanted to be photographed to preserve some evidence of their presence there. Later on, as the relationship between the U.S. government and the Native Americans continued on its disastrous downhill course, the Indians were sometimes required to pose, both head on and in profile, for photographers working for the military or the Bureau of Ethnology. Their resistance to being photographed grew, though not always where it might be expected. Chief Red Cloud, for example, often refused to let his picture be taken, but Geronimo did not. Although he defied the military for many

years, after his capture in 1886 he posed frequently, and he charged to have his picture taken according to a sliding scale.

Even when cooperation was volunteered, however, early portraits often look stiff to us. Exposure times, which were reduced from three to five minutes in 1840 to a few seconds by the 1880s, required patient cooperation between subject and photographer, not to mention the use of head clamps and chair braces to help the subject hold the pose. Later on, convention continued to dictate decorum and formality, especially in portraiture. Yet despite fixed expressions and unnaturally held bodies, individuality remains.

Our knowledge of the sad and violent history of the Native Americans during these years makes these images even more forceful. Yet although it is tempting to view a collection such as this one from afar, through the long lens of history, these pictures disallow such distancing. Only incidentally do they illustrate the vast sweep of change; instead, each one offers a glimpse of an isolated encounter, a frozen moment in the lives of two human beings: the person (or group) whose image we see and the person who took the picture. The stories of the photographers are as remarkable as those of the people they photographed.

Often immigrants, adventurers all, these pioneers of photography participated in the creation of a new medium of communication and a new art form. Among them were Civil War veterans, ethnographers, entrepreneurs, crusaders for Indian rights, writers, editors, booksellers, innkeepers, and prospectors for gold. Many worked for the military, in photographic studios attached to forts throughout the West that were established to protect white settlers from Native Americans. Others were hired by the railroads, which, as they crisscrossed the country, used

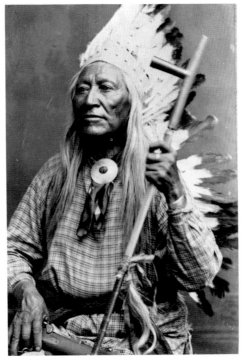

the image of the Indian to titillate the public. In 1866, for example, Pawnee Indians were hired to entertain a railroad excursion by staging a mock raid, an event for which they were paid with trinkets, beads, and cash up front. Photographs and stereoscopic views were intended to convince ticket buyers that the Indians were "picturesque" but posed no threat—something that wasn't strictly true.

Some of the most important photographers worked for the government expeditions that explored the West between 1867 and 1879. Known as the Four Great Surveys, these expeditions were mandated to chart the geological, geographical, and man-made features of the West. Working in tandem with the War Department and the railroads, the surveys sometimes mapped the land with an eye towards which Indian villages would have to be moved so that the tracks could go through. The members of these expeditions included scientists, soldiers, and photographers hired to provide visual documentation of the land and of the people.

Some of these photographers were specifically interested in the Indians. Others, lured west by vistas of mesa, mountain, canyon, butte, and falls, were more inspired by geography than by people. Like other pioneers, they faced wolves, rattlesnakes, poisonous centipedes, harsh weather, floods, river rapids, and hostile Indians. Their journeys were complicated by their photographic apparatus. Traveling by wagon train or mule across the desert and through the Rocky Mountains, they carried hundreds of pounds of fragile, cumbersome equipment: large cameras, lenses, tripods, developing trays, varnish, bottles of chemicals, and hundreds of glass plates for negatives. Once they unpacked, set up their equipment, and took the picture, they had to develop the negative immediately, often under makeshift conditions, in "black tents" lined with calico. They photographed sites never previously seen by anyone other than the Native Americans, and those pictures are spectacular. More riveting still are the pictures they took of a people whose traditional way of life was in extreme flux.

Certain elements of the pictures are questionable. Even photographers whose aims were ethnographic were often subverted by their own methods. The Indians were not necessarily photographed in their own environment or even in their own clothing. Nor were the photographs always labeled. Subjects and tribal affiliations were unidentified, dates were omitted, and even the photographer's name is often a matter of conjecture. One photographer's negatives might be sold to another and subsequently relabeled with the second photographer's name; a Laton Huffman photograph, for instance, might have been taken by Christian Barthelmess; a picture ostensibly by C. C. Pierce could easily be the work of George Wharton James. Piracy was rampant; many photographs were copyrighted at separate times by more than one person. And many photographs exist for which we have no information whatsoever. Consequently, correct attribution is often difficult or impossible.

Because of the problems of attribution, the role of women in photography cannot be accurately documented. The photographers included in this collection were almost all born before 1880, the year when the first newspaper photograph was published. Despite the hardships of early photography, literally hundreds of women born before that watershed date became active photographers, but few are known; the overwhelming majority of pictures in this collection, as in others from the same period, are credited either to men or to "Anonymous." As we

know today, Anonymous was often a woman, but there is another reason to suspect that more of these pictures than we realize may have been taken by women. Photographic studios were often family businesses in which wives or daughters participated fully. When male photographers traveled, or when they died, the women maintained business as usual. Those photographs were inevitably credited to the male.

It is true that many of the photographs in this book suffer from a woeful lack of information regarding the Native Americans, the photographers, and the circumstances of the picture. Yet the impact of these images is powerful, for the faces in these pictures are filled with intensity, intelligence, anger, sorrow. Laboring under difficult conditions, the photographers who took these pictures produced a body of work that still communicates strongly. The collection that appears in these pages is only a fraction of their rich legacy.

Pre-eminent among the early photographers was Alexander Gardner (1821–1882). The pattern of his life, which ricocheted from one extreme to the other, was quintessentially American. Born in Scotland, he was trained as a jeweler, a chemist, and a photographer, but when he came to this country in 1849 with his brother-in-law, his purpose was to set up a cooperative community in Iowa based on the teachings of the socialist Robert Owen. He returned to Scotland and brought his family back with the intention of settling in Iowa. When he discovered that the visionary farming community was in the midst of an epidemic, he changed his mind about utopian living and moved to New York City.

There he found employment in the studio of Mathew Brady, a portrait photographer who won a prize for his daguerreotypes at the Crystal Palace Exhibition in 1851 but is best known for his role in photographing the Civil War. Brady was interested in Gardner primarily because Gardner had a firm grasp of a major technical advance: the collodion process. Invented in 1851, collodion was a chemical used to coat a glass plate, which had

to be developed while still wet. It was a time-consuming, complicated procedure with a big pay-off: unlike daguerreotypy, which produced only a single image, the wet-plate process enabled the photographer to make multiple paper copies of the picture. Brady opened a gallery in Washington, D.C., in 1858 and put Gardner in charge of it. During the Civil War, when Brady organized a corps of photographers who took some of the most dramatic and unflinching pictures of that conflict, Gardner was among them. But Brady had a policy not unlike that of many other nineteenth-century photographers: he took credit for everything produced by his studio. The studio name appeared on the photograph, but the name of the actual photographer did not. Eventually this came to irk Gardner. In 1862, he left Brady's employ, joined the army of the Potomac as a photographer, and produced two thousand negatives. Among them were portraits of Abraham Lincoln, whom he photographed on three different occasions: in August 1863; in November of that same year, just four days before the Gettysburg Address; and on April 9, 1865, the day Robert E. Lee surrendered at Appomattox.

When the war ended, Gardner continued to work in his Washington, D.C., studio, where he took pictures of delegations of Native Americans who came to negotiate treaties and agreements. Gardner also went back and forth to the Midwest to visit members of his family who had stayed in the planned community, which had by then relocated to another Iowa town. In 1867, he took a stereoscopic twin-lens camera, loaded up his "photographic buggy," and rode west with the Kansas Pacific Railroad to document its construction across the prairie. Afterwards, his wanderlust apparently sated, he returned to the capital, where he continued to photograph Indians who came east to meet the President. According to one frequently repeated story, he, like other gallery owners, routinely kept a collection of Indian costumes in his gallery as props; his wife complained of the smell. He also worked with the police department in Washington,

establishing a collection of photographs of criminals. When he died in 1882, the idealistic socialist was a successful man, thanks to his photographic skill and to his savvy investments in real estate.

William Stinson Soule (1836-1908), best known for his pictures of Southern Plains Indians, was wounded in action at Antietam. After the war, he returned to his studio in Chambersburg, Pennsylvania. When it burned down a year or so later, he sold everything and headed west. He got a job as a clerk at Fort Dodge and started to photograph the Indians. He also photographed, on December 7, 1868, a local sheepherder who had been killed and scalped by the Cheyenne an hour earlier. His first published picture was an engraving made from that photograph and printed in *Harper's Weekly*. When he became the official photographer at Fort Sill in the Oklahoma Territory in 1869, he was very much aware of the commercial possibilities of his photographs. Five or six years later, he moved to Boston, where his brother John copyrighted many of the pictures and sold them individually and in albums. Like other pictures

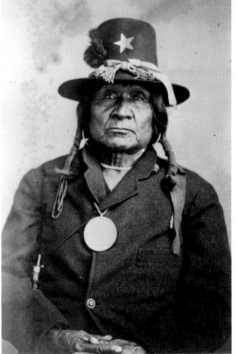

taken during this time, Soule's portraits are relatively simple, straightforward compositions, often showing the Indians wearing various combinations of white and Indian clothing.

Perhaps the most important contributions were made by the photographers who accompanied the great expeditions. One of them was Timothy H. O'Sullivan (1840–1882). Born in Ireland, he was a lean loner, intense and uneducated, who apprenticed to Mathew Brady at an early age and became a member of his group of photographers during the Civil War.

During the last part of the war and for a few years thereafter, he worked with Alexander Gardner, who had broken from Brady to set up his own studio. Brady tried to woo O'Sullivan back, but Gardner, unlike Brady, gave credit where credit was due, and O'Sullivan stayed with him. He photographed almost every major battle of the Civil War, from the Second Battle of Manassas up to the surrender at Appomattox. He was so much in the thick of things that his camera was destroyed by a stray shell at Bull Run. To the irritation of almost everyone he knew, he never stopped bragging about his wartime experiences, but they were by no means the only action in his life.

In 1867, O'Sullivan joined Clarence King's Geological Exploration of the 40th Parallel, a survey intended for use by the Central Pacific Railroad. The expedition sailed to California by way of Panama. In Nevada City, O'Sullivan used burning magnesium wire to produce enough light to take pictures inside the Comstock Lode. From there, the group headed east. The journey was difficult. In an article about the Humboldt Sink area published in *Harper's Weekly* in 1869, O'Sullivan was quoted as complaining about "voracious and particularly poisonous mosquitoes" and "that most enervating of all fevers, known as the 'mountain ail.'...We were, in fact, driven out by the mosquitoes and fever. Which of the two should be considered as the more unbearable it is impossible to state."

Over the course of the expedition throughout California, Nevada, and Utah, they lost equipment, suffered from lack of water in the desert (a problem for O'Sullivan when he was developing negatives), almost drowned in a river, and struggled with

their mules through snow-covered mountain passes. O'Sullivan, whose supplies were housed in an old army ambulance carted by two mules, took spectacular pictures of the scenery. He also photographed the Mojave and Paiute Indians. Relationships with the Indians were tentative at best, however, for the Shoshoni were on the warpath, afraid that the true purpose of the expedition was to kill the Indians in Nevada. They weren't wrong to worry. Although after the survey was completed Clarence King wrote poetry that he illustrated with O'Sullivan's images, the true purposes of the survey were anything but poetic; in addition to charting geological features, the covert aim of the expedition was to provide information to the War Department about the Indians.

Following a short foray to Panama, O'Sullivan signed up with another expedition, this time a U. S. Army survey in the Southwest. This one also had a double purpose: to survey all the features of the area including roads, towns, mines, and dams; and to provide intelligence to the army, which, under General Crooks, was attempting to force the Apache and the Paiute Indians out of the area. The survey was led by Lt. George M. Wheeler, a man who was accused of torturing Indian guides and who forced his men to march across Death Valley during the middle of the day (the temperature reached 120°, causing O'Sullivan's photographic chemicals to boil over). On this survey, O'Sullivan took some of the first pictures of the Grand Canyon, but this trip too was plagued with problems. The group navigated up the Colorado River, against the current, and then back down, O'Sullivan in a boat he named *The Picture;* at one point, rations and supplies were swept overboard and O'Sullivan had to jump into the river to save some materials. Over the course of the expedition, one boat was wrecked, another developed a bad leak, and almost half of the original crew either drowned, deserted, or otherwise disappeared.

At last, on November 5, 1871, O'Sullivan prepared to return to Washington with Frederick H. Loring, a Boston journalist who had accompanied the expedition. Four hours before they were due to leave, O'Sullivan was still taking pictures, including one of Loring. When the time came to leave, O'Sullivan wasn't ready, and Loring caught a stagecoach and went on without him. A short time later, Apaches attacked the stagecoach and killed Loring, taking Loring's notes, some gold, and many of O'Sullivan's photographs of the Indians.

On his return to Washington, O'Sullivan made twenty-five hundred copies of his pictures, which were bound into albums intended to illustrate Wheeler's multivolume report to Congress. Afterwards, O'Sullivan returned to the Southwest, where he acted as a liaison between the army and the civilians. In 1880, he became official photographer for the Treasury Department, but had to resign because of illness. An intrepid adventurer who had put his life at risk many times in the service of photography, he returned in 1882 to his father's house on Staten Island, where he died of tuberculosis. He was forty-two years old.

Yet another expedition photographer was John K. Hillers (1842–1925), a German immigrant who fought in the Union Army and was a Brooklyn policeman before traveling west with a sick brother. In California, Hillers worked as a mule driver. When he heard that silver was to be found in Colorado, he headed towards the Rocky Mountains. In a hotel one night in 1871, Hillers overheard expedition leader John Wesley Powell talking about a planned expedition down the Colorado River. He offered

his services as a crewman and was instantly hired.

Powell was a character in his own right who had lost an arm at the Battle of Shiloh, liked to read Sir Walter Scott aloud while traveling through the canyons and once directed an expedition of the Green River via hand signals given from an armchair strapped atop the boat. Over the course of the Colorado River expedition, Hillers started following around and carrying heavy equipment for photographer Edward O. Beaman. Beaman was widely disliked, and when he left, Powell's cousin, Clem Powell, took over. He proved to be incompetent, so Powell hired a London-born photographer from Salt Lake City named James Fennemore. (Fennemore had earlier been charged with treason for his participation in the Wooden Gun Rebellion. During that incident, in 1870, he and a group of other Mormons, equipped with wooden guns, marched into a town square.

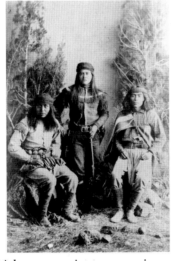

The United States government, which was waging a campaign against the Mormon Church over, among other issues, its acceptance of polygamy, cracked down immediately.) Once again, Hillers volunteered to help, washing and polishing glass plates, making a "dark tent," fixing tripods. When Fennemore got sick and had to leave, Hillers was appointed official expedition photographer.

The relationship between Hillers and Powell was cemented on that trip down the Colorado when Hillers and some other men fell into the river after a boat overturned. Hillers was able to get out (although he lost his shoes and socks to the raging current), and, a few minutes later, when Powell was pulled into the rushing waters, Hillers jumped in and saved him. The expe-

dition was cut short when Powell was warned by Mojave guides that the Paiute intended to attack, but the association between Hillers and Powell continued until Powell's death in 1902. When Powell became director of the Bureau of Ethnology in 1879, Hillers became the official photographer, and when Powell was appointed director of the U.S. Geological Survey, Hillers also worked for that organization. During the seven years of the Powell Survey, Hillers took

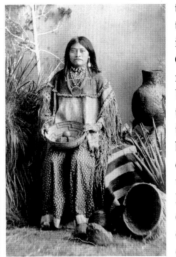

thousands of pictures of Indians, including Creeks, Seminoles, Cheyennes, Cherokees, Shoshonis, Zunis, Hopis, Paiutes, and Utes. As anthropology, these photographs are not always trustworthy, for Powell was fond of the buckskin and the feathered headdresses of the Plains Indians and wanted the Indians who posed for Hillers to wear those costumes even when they came from entirely different areas of the country and dressed differently. Still, unlike

many other photographers, Hillers was able to develop rapport with his subjects, and his pictures show it. His photographs of Native Americans, numbering over twenty thousand, are considered to be some of the finest of the era, both in the way they reveal aspects of Native American life and in their artistic quality. In certain ways, Hillers and Powell, who worked in conjunction with artist Thomas Moran, anticipated later developments by setting up idealized and carefully posed scenes. For Powell and for Hillers, as for photographers of a later time, the fantasy of the mythic Indian occasionally overrode the reality of a hungry, sometimes hostile, people who had been dispossessed.

William Henry Jackson (1843–1942) was a major photogra-

pher who worked in New York and Vermont prior to serving in the Union army not as a photographer but as an artist. Unlike Alexander Gardner and Timothy O'Sullivan, who saw action, Jackson spent most of his time in Washington, D.C., where he frequented the Smithsonian. After the war, he went to California and made his way back east as the driver of a herd of wild mustangs. In Omaha, he set up shop and drove around the countryside with a one-horse darkroom, taking pictures of Indians and scenery. But he found the small radius of these local travels frustrating, and, leaving the studio in the management of his wife, signed up as a railroad photographer. In that capacity he met Dr. Ferdinand Vandeveer Hayden, a University of Pennsylvania professor who, during his summer vacations, led a government survey. Hayden invited him to join his survey of the Great Basin. Although it was an unpaid position, Jackson accepted. As the photographer with that expedition, he went everywhere: Yellowstone, the Grand Teton Mountains, Pike's Peak. Often he was the first person to photograph these sites, and he became famous as a result.

Jackson also took many pictures of Indians. For him as for other photographers, the process was difficult. Sometimes, technology interfered; once, he lost over four hundred pictures when a new dry-plate process he was experimenting with turned out to be flawed. Other times, the problem was interactional. Unlike Hillers, Jackson was not especially adept at overcoming the resistance of the Indians to being photographed, which was strong at this time. In a book published in 1877 entitled *600 Portraits of American Indians* and consisting primarily of pictures taken by Jackson, Hayden complained of the trouble involved in photographing Indians. "The American Indian is extremely superstitious, and every attempt to take his picture is rendered difficult if not entirely frustrated by his deeply rooted belief that the process places some portion of himself in the power of the white man, and such control may be used to his injury." We might question whether this was superstition or justifiable cau-

tion. In any case, such incidents did occur. In 1874, the Uncompahgre Utes refused to be photographed because they saw the camera as an instrument of death. Another time, Jackson's camera was attacked as a "strange box of bad medicine." Eventually, the story goes, Jackson and his assistants were able to overcome the Indians' resistance by staging an impressive demonstration of marksmanship, after which Jackson was allowed to take pictures freely. But his true interest was scenery, not people. "Portrait photography never had any charms for me," he said.

Jackson lived to be ninety-nine years old. For his ninetieth birthday in 1933, the photographer who had once trekked through the Rockies with four hundred glass plates and three hundred pounds of photographic equipment loaded on a mule named Hyposulfite of Soda (Hypo for short) was given a Leica camera. "This little thing makes a sport of our labors," he said. His labors were not ended, however. Five years later, at age ninety-five, he worked as technical advisor for the film *Gone with the Wind*. He died in 1942.

The 1880s were a time of great transition for photography. At the beginning of the decade, most photographers still used the wet-plate collodion process—a procedure that was particularly cumbersome for landscape photographers. By the end of the decade, the faster, lighter dry-plate process had taken over. In addition, film had been invented, along with the simple box camera.

These same years brought further sorrow to the Indians. In 1876, the Native Americans defeated Custer at the Battle at Little Big Horn, one of the most Pyrrhic of victories. The 1880s saw the virtual extinction of the buffalo and, according to the official census of 1890, the frontier. The reservation system became entrenched and even more restrictive. Areas previously designated as Indian land—such as the Oklahoma Territory—were opened up to white settlement, and Indian land allotments were carved into increasingly smaller portions. In 1886, after years of

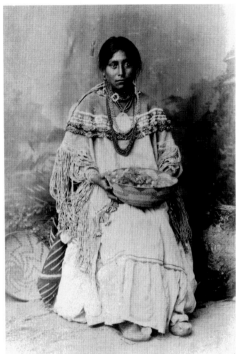

struggle, even Geronimo quit the warpath.

During this period, photographers were working throughout the West. Camillus S. Fly (1849–1901), a prototypical resident of the Wild West, was hardly the best of them. Fly's photographic career began in 1879 when he opened a studio and boarding-house with his wife Mollie in Tombstone, Arizona: the "Town Too Tough to Die." Although his photographs were not masterpieces, he is remembered for two reasons: one failure and one success. The failure occurred when he became possibly the first photographer to miss a major photo opportunity: the shoot-out at the OK Corral. It happened directly outside his studio in the middle of the afternoon, and he was inside. When the dust cleared, Fly showed up, rifle in hand. His camera remained safely in the studio.

His great success occurred in 1886, when he rode to Mexico with Gen. George Crook to meet with Geronimo, who had escaped yet again from the San Carlos Reservation. In Mexico, Fly took a series of important photographs of the great warrior. When they were published in *Harper's Weekly*, Fly became quite well known. An alcoholic, he never equalled that accomplishment again. His marriage was rocky, a series of studios he established went out of business, and he was a persistently unsuccessful prospector for ore.

Far more successful was Laton Huffman (1854–1931). In 1878, he established a studio in Montana at Fort Keogh, which had been named for an army captain killed at the Little Bighorn two years earlier. As a result of that battle and the subsequent heavy retaliation by the military, Sioux prisoners of war were housed in camps outside the fort. Throughout the 1880s, Huffman photographed many aspects of military life, including the defeated Indian tribes who set up camp nearby. He used

dry plates and was no longer tethered, as earlier photographers had been, to the tripod; he even took pictures from horseback. Perhaps more than any other photographer of the time, he was disturbed by what he saw. He objected to the extermination of the buffalo; to the barbed wire fences that subdivided the land; to the cowboys; and to the railroads, which he called "the fatal coming." By the close of the decade, he was painfully aware of the passing of the frontier. "A dream and a forgetting, a chapter forever closed," he called it, whereupon he stopped taking pictures and went to Chicago. Three years later he was back in Montana, where he briefly became a member of the state legislature. He stayed in Montana for the rest of his life. During his early days at Fort Keogh, Huffman sold buffalo hides as well as photographs. Two decades later, his entrepreneurial impulse reasserted itself. Realizing that his photographs could be marketed to his advantage, he began to reproduce them profitably in a variety of forms. Of all his pictures, his portraits of Indians were the most commercially successful.

Another photographer connected to the military was Christian Barthelmess, a German immigrant who left his native country in the 1870s to avoid conscription and enlisted in the U.S. Army shortly thereafter. A member of the military band, his interest in Indians was stimulated when he was sent to the Southwest, where cavalry forces were posted to defend white settlers against the Native Americans. During the 1880s, while he was stationed at Fort Apache in Arizona and at two forts in New Mexico, he photographed Navajo ceremonies, researched Zuni customs, and wrote for a German-language newspaper published in Chicago. In 1888, he was transferred to Fort Keogh, Montana, where Huffman had been post photographer a few

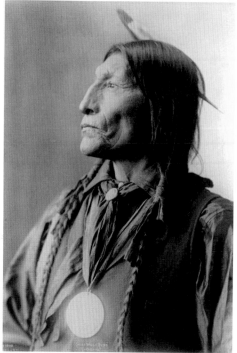

years earlier. He spent the next decade photographing Indian reservations and recording the white social life of the time. After a few years overseas, he returned to Fort Keogh, where he continued to take pictures as a civilian until his death in 1906.

In 1890, the Indians met their final defeat. It was linked to what the whites called the Ghost Dance religion. Arising first in Oregon in the 1850s, the movement reached its culmination in the late 1880s, when a Paiute Indian named Wovoka had a series of visions that led him—and others—to believe that he was a messiah. The central ceremony of this intertribal belief system was a circular dance: Wovoka and his followers, an ever-increasing group for a while, believed that if these dances were performed in the right way, if certain words were sung and a certain kind of paint were used, the ancient Indian ways would return. Although today the Ghost Dance religion seems more than anything an emblem of despair, it swept across the West and was highly threatening to whites. The fears it aroused led directly to the fatal shooting of Sitting Bull in December 1890 (because the great warrior was erroneously believed to be an important Ghost Dance leader). Two weeks later, the Indians were massacred at Wounded Knee, the final shudder of the Indian Wars.

By then, more white people began to oppose government policy and commit themselves to the cause of the Indians. One of these people was Charles Lummis (1859–1928). Born in Massachusetts, where he attended Harvard University and became friends with Theodore Roosevelt, Lummis was a journalist who in 1881 worked for a newspaper in Ohio. In 1884, he gave in to his boyhood attraction to the West by negotiating a deal with the *Los Angeles Times*. He contracted to walk from Ohio to Los Angeles and to send a letter each week to the *Times*,

of which he eventually became city editor. Inspired by the books of Helen Hunt Jackson, who wrote *A Century of Dishonor* in 1880 and the best-selling novel *Ramona* in 1884, he fell in love with Hispanic culture and covered the Apache Wars. In 1887, at the age of 28, he had a paralyzing stroke. After that, he purchased his first camera and moved to New Mexico, where he photographed the Brothers of the Penitente, a religious order that ritually re-enacted the crucifixion every spring. No one would publish his photographs, which were shocking in their day, and, as predicted, assassins hired by the order shot and almost killed him. Nonetheless, he stayed on with the Indians and over the years became a crusader on their behalf. He became editor of *Land of Sunshine*, a magazine about the Southwest, and, throughout his lifetime, published many books of prose (*The Man Who Married the Moon*, *The King of the Broncos*, and *A New World David*, among others) as well as many slim volumes of poetry printed on birch bark and collectively titled *Birch Bark Poems* (copies of which he sent, early in his career, to Walt Whitman, Ralph Waldo Emerson, and Henry Wadsworth Longfellow). As a photographer, he is admired less for his aesthetics than for his commitment to the Indians.

During this same period, photography changed, due in large measure to Kodak, which produced a camera anyone could use. For $25 anyone could buy a camera loaded with film. When the roll of one hundred pictures was finished, the entire camera could be returned to the company, which developed the film and sent back the pictures along with the camera, loaded with a new roll of film. Photography was becoming a daily reality, and for the first time, amateur photographers outnumbered professionals.

Perhaps the most inspired of the amateurs was Adam Clark Vroman (1856–1916), a cultured, curious man who came west in 1892 due to his wife's ill health and opened in Pasadena a bookstore that still exists. His wife died, but he loved the West and stayed on. Thanks to the influence of Charles Lummis, he became interested in photography and added a Kodak dealership to the bookstore. A year after opening his store, he visited the Southwest—a trip on which he went camping for the first time—to see the Hopi Snake Dance, which had become a tourist attraction. Vroman was profoundly affected by the ritual. One of the difficulties he faced in photographing it was that casual picture-takers often interfered; when Vroman returned to see the Snake Dance two years after his first trip, the number of tourists had tripled. Vroman's interest extended beyond ceremony to ordinary events. In his contacts with the Indians, Vroman was able to establish trust, and the calm intimacy of his photographs reflects this. For ten years, he traveled around California, visiting missions and taking pictures of Indians, often in company with the members of his camera club. He returned to the Southwest a total of seven times; his apartment filled up with rugs, baskets, pottery, and other Indian objects. But after a decade of picture taking, his interest in the Southwest waned, and he turned instead to Japan. When he died in 1916, he donated his photographs to the Pasadena Public Library and his artifacts to the Southwest Museum. His collection of netsukes is now in the Metropolitan Museum of Art.

By the time Vroman made his first trip to the Southwest, the Indian population was close to its all-time low, and the Indian Wars were only a memory. With the Indians confined to reservations, and the threat of their presence eliminated, photographs of them became increasingly popular; between 1890 and 1920, stenographs, postcards, and photogravures were sold by the hundreds of thousands. At the same time, the style of photography had changed. The romanticism hinted at in Powell and Hiller's manipulations came to full flower as part of a movement called Pictorialism. Pictorialism began in England, where photographers were taking country scenes so idyllic they verged on fantasy. It took determination to create these images. Henry Peach Robinson fused several negatives together to create his scenes; Peter Henry Emerson, generally considered the father of Pictorialism, reacted against that technique, considering it artificial, yet Emerson performed artificial maneuvers too: he eliminated contemporary details from his negatives, and he once went so far as to have the roof of a rural cottage removed in order to change the lighting within and create a different atmosphere. In the United States, Edward Stieglitz, Gertrude Käsebier, and others were also drawn to the techniques of Pictorialism, which attempted in many ways to imitate painting in general and Impressionism in particular. Professional photographers simulated painting with the use of soft-focus, cropping, retouching, and other techniques. Pictorialism overtook realism; it reflected a shift towards romanticism but it also served to distinguish the professionals from the hordes of amateurs taking credible, and often far more realistic, snapshots. The photographs of the Pictorialists are almost painterly, luminous with empathy and imagination. In some ways, they represent a triumph of art over reality. But in the West, the photographers of the Indians didn't think of it that way.

Instead, they believed that by manipulating the look of the pictures and of the people they were photographing, they were achieving a greater realism: rather than revealing the poverty and despair that affected the lives of many of the Native Americans, they were presenting the majesty of the past, the details of which were disappearing daily with every Indian who died. They didn't think they were Romantics; they thought they were archivists, saving what bits of the past they could. Their intention was not to distort the present but to preserve the historical truth.

Nowhere is that odd blend of romanticism and reality more generally seen than in the work of Edward S. Curtis (1869–1952).

Curtis, who like to be called "Chief" by everyone, including his children, is the most famous of the Indian photographers. From 1900 to 1928, he traveled throughout the West, visiting more than eighty tribes and taking more than forty thousand pictures. He tried to recreate the image of a time already receding into memory by carefully posing his subjects and retouching photographs to eliminate modern details. In addition to creating atmosphere photographically, Curtis carried such items as clip-on nose bones and long wigs for Indian men to wear, since by then they all had short hair. As a result, he has been accused of inaccuracy, exploitation, racism, excessive romanticism, and "patronizing absurdity." Yet it was not history that he cavalierly ignored but contemporary influences: he did his best to create an image of the past informed by accuracy and suffused with love. Besides photographing the Indians, he recorded their speech, their vocabularies, and their music. His critical fortune has fluctuated in the years since he died in relative obscurity in 1952. Today, the idealized vision created by Curtis and other twentieth-century Romantics still strikes us as poignant.

Curtis was by no means the only photographer influenced by Pictorialism. Another photographer, well known in his day, was Carl Moon (1879–1948). Moon became interested in photography after a stint in the Ohio National Guard. He worked in Ohio, West Virginia, and Texas before moving to Albuquerque, New Mexico, in 1903. His pictures of Indians, created by way of soft-focus, vignetting, cropping, retouching, and drawing on the finished print, were published widely and exhibited, among other places, at the Museum of Natural History and the White House, by request of President Theodore Roosevelt. For seven years, he worked at the Grand Canyon in partnership with photographic dealer Fred Harvey, creating an archive of Southwest Indian pictures. In 1914, he and his wife Grace, an artist and writer, moved to Pasadena, where Moon concentrated on painting rather than photography. He also made pen-and-ink drawings for many children's books, including those written by his wife. In 1924—the year that Native Americans were finally granted citizenship—he put together a collection of one hundred photographs taken in Arizona, New Mexico, and Oklahoma. *Indians of the Southwest* consisted of four handmade books and cost a mere $3,500. Less than a dozen sets were ever produced. (Curtis, in contrast to Moon, was financially supported by J. Pierpont Morgan.) Although Moon's popularity waned, his pictures are as affecting today as they were when they were made; the romanticism inherent in them stayed within the bounds of the reasonable.

Roland Reed, on the other hand, often strayed beyond those bounds. For him, Indians were romanticized right from the beginning; when he was seven years old and growing up in Wisconsin, a group of Menomini Indians rescued two teenage schoolboys who had paddled a canoe across a lake with their teacher in order to gather greenery. On the way back, the canoe overturned. The teacher drowned, but the boys hung on until the Indians rescued them, took them ashore, and warmed them up by feeding them hot liquids and keeping them overnight in a haystack. From then on, Reed's view of the Indians was essentially a heroic one. He wandered everywhere, from El Paso to Alaska, photographing Indians along the way. The only Indians he apparently did not photograph were a group of hostile Apaches (who laughed at him and shortly thereafter killed a storekeeper) and the Native Americans of Alaska; when he sailed to the Klondike in 1897—Jack London was on the same boat—he found the people there uninspiring. In the twentieth century, however, he found inspiration among many tribes, including the Ojibway, the Chippewa, the Piegan, and the Navajo. The scenes he created—they were given titles such as *Alone with the Past, The Echo's Call,* and *The Wooing,* a picture for which he conducted a virtual casting call within a thirty-mile area—required enormous preparation. The dramatic pictures that resulted are sometimes silly but often moving mementoes of an imagined past.

The inhabitants of the far north, whom Reed found so uninteresting, were photographed in the early years of the twentieth century in a straightforward manner more reminiscent of the pictures taken during the 1870s and 1880s than of the Pictorial images being created by Curtis, Moon, Reed, and others. Perhaps the reason is that the photographers in Alaska during the years following the gold rush were pioneers, like the men who rode the rails and trekked across the Rockies with the great expeditions. Perhaps because their vision was one of a glorious future, they saw little need to romanticize the present. The Pictorialists, who hearkened back to a glorious past, found it harder to accept the reality in front of them.

From 1862, when the earliest picture in this book was taken, to 1918, when the last one was shot, photography grew from an infant art to a developed one. Since then, the notion that photography represents reality has come increasingly into question. Today, although we still look to pictures in the newspaper to give us reliable information, we know that the great mystery of photography is that it only appears to represent reality. Stereotype and selective perception affect it fully; photographers shape our vision of the world not only by what they choose to focus on but by what they omit. The photographs in this book were taken during an extremely painful period of Native American history. The directness of image and of gaze, particularly in the early pictures, was not always matched by a directness of purpose on the part of the photographers. Their motivations were both artistic and commercial, ethnographic and Romantic. The case could be made that, more than anything else, these pictures reveal the perceptions of certain white men (and a few women), all of whom were born before the surrender of Geronimo, before the death of Sitting Bull, before Wounded Knee. They lived during a time when the Native Americans were still widely thought of by whites as a primitive people whose time had passed. Yet these photographers were a hardy, curious group, pioneers of perception, preservers of the passing shadows of place and personality. Whether they snapped these pictures on an expedition charting the West, as part of their duties for an army trained to fight the Indians, or in an attempt to reassert the beauties of Native American culture, the universal humanity in these portraits shines through. Although the people in these photographs are long dead, their faces speak to us still.

Nancy Hathaway

PORTRAITS

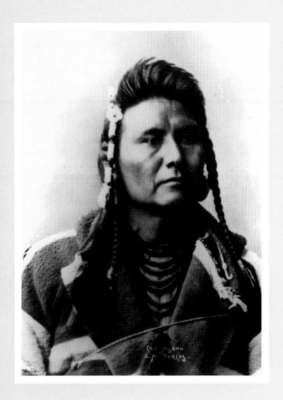

"... Hear me, my chiefs! I am tired; my heart is sick and sad.

From where the sun now stands I will fight no more forever."

Chief Joseph

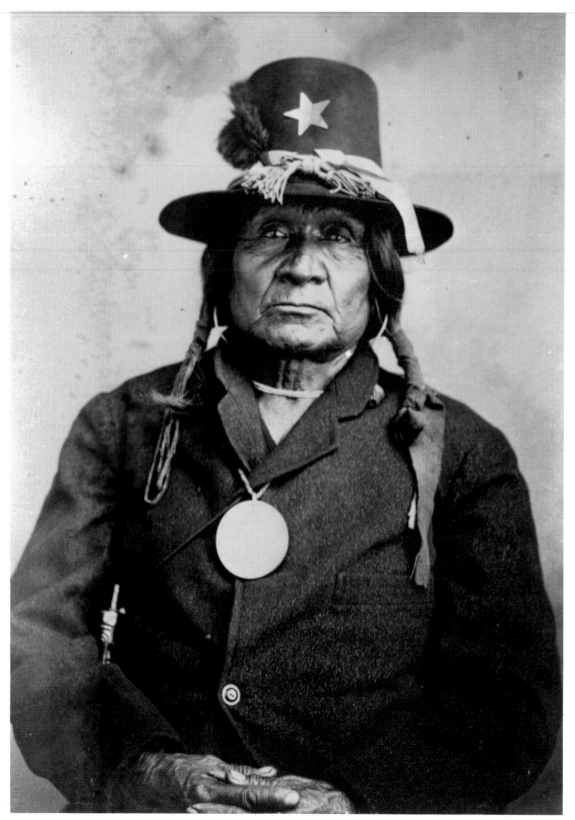

William S. Soule (1836–1908)
Chief Tosh-A-Wah (Tosawi), Comanche
1868
albumen print
3$^{15}/_{16}$" by 5$^{13}/_{16}$"

After being wounded in action in the Civil War, Will Soule clerked at a store in Fort Dodge, Kansas, and then became official photographer at Fort Sill, Oklahoma. His pictures, distributed by his brother in Boston, became immensely popular. In these portraits, Chief Tosh-A-Wah is wearing a "Jeff Davis" hat, while Bird Chief dons a cavalry hat with a bugle. Both men are wearing presidential peace medals.

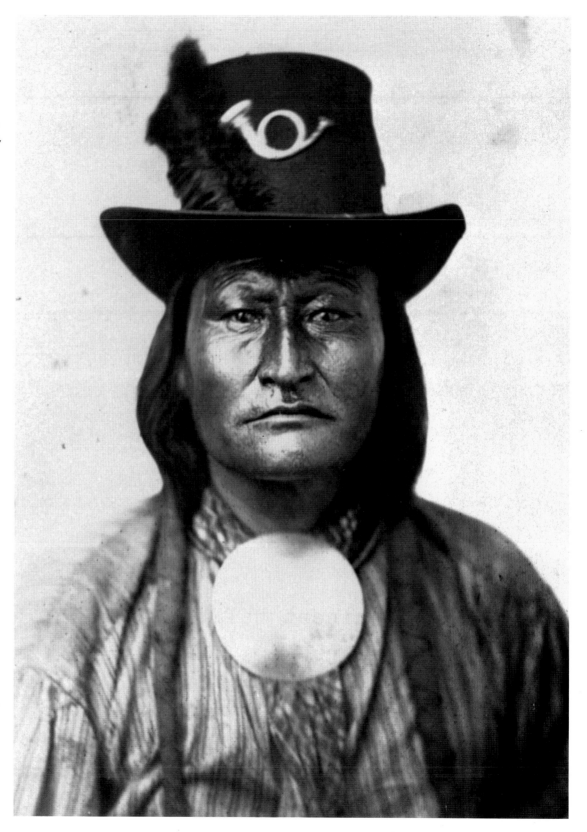

William S. Soule (1836–1908)
Bird Chief, Prominent Chief of the Arapahoe
date unknown
4" by 6"

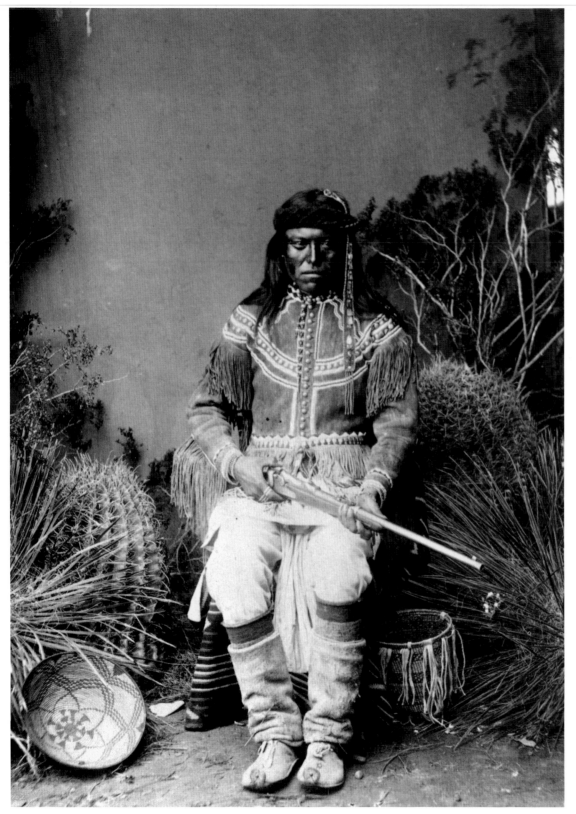

In the 1840s, it was found that coating photographic glass plates with albumen helped to preserve detail. Ten years later, albumen paper was introduced. It was widely used for the rest of the century—so much so that in 1894 a German manufacturer cracked sixty thousand eggs a day in the course of production.

Unidentified Photographer
Indian Portrait
1860s
albumen print
6¼" by 8"

18

The studio trappings in this photograph provide a peculiar counterpoint to the ambivalent body language of the people. Note the griffin—a mythical creature with the head and wings of an eagle and the body of a lion—in the upper left-hand corner.

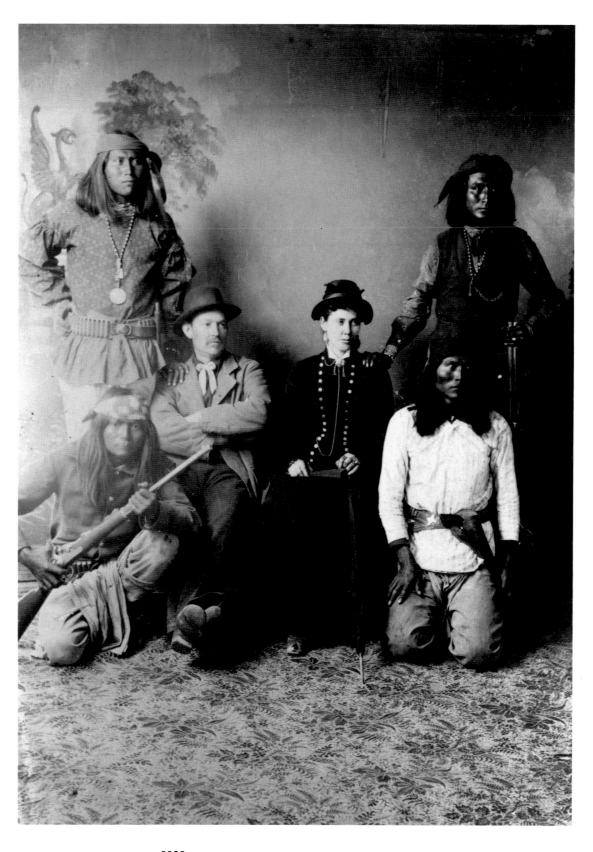

Unidentified Photographer
Indians and Whites
1860s
albumen print
6¼" by 8⅛"

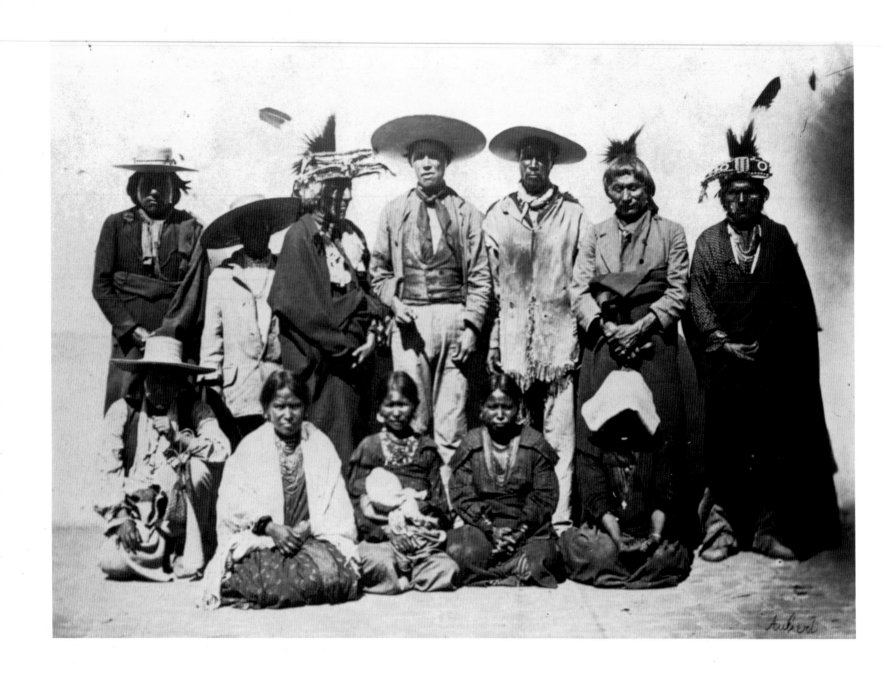

Aubert
Deputation d'Indiens du Pacifique venue
Près de Maximilien en 1866
1866
8¼" by 6"

(left) Maximilian, younger brother of the emperor of Austria, became emperor of Mexico in 1864, shortly after the French captured that country. After the Union won the Civil War, the French withdrew, and Maximilian was court-martialed and shot.

(right) A Santee Sioux, Tehedo Necha took part in the Minnesota Uprising of 1862, in which the Indians, starving and denied the money pledged them by treaty, massacred 700 settlers and 100 soldiers. A military commission sentenced 303 Sioux to death by hanging, but Abraham Lincoln overturned most of those sentences. In December 1862, thirty-eight Santees were executed. Tehedo Necha was among them.

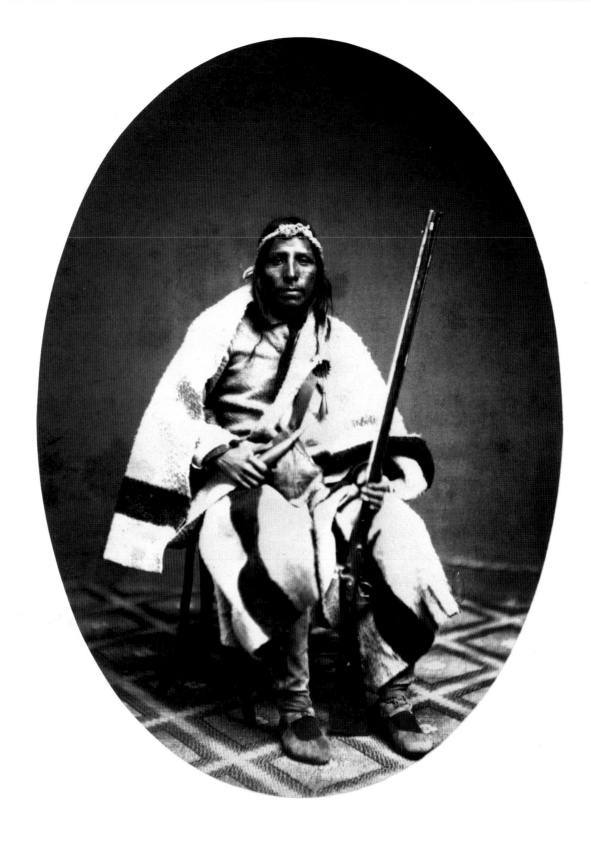

H. H. Whitney
Te-He-Do-Ne-Cha (Tehedo Necha, or One Who Forbids His Home)
1862
salt print
5³⁄₁₆" by 7¹⁄₄"

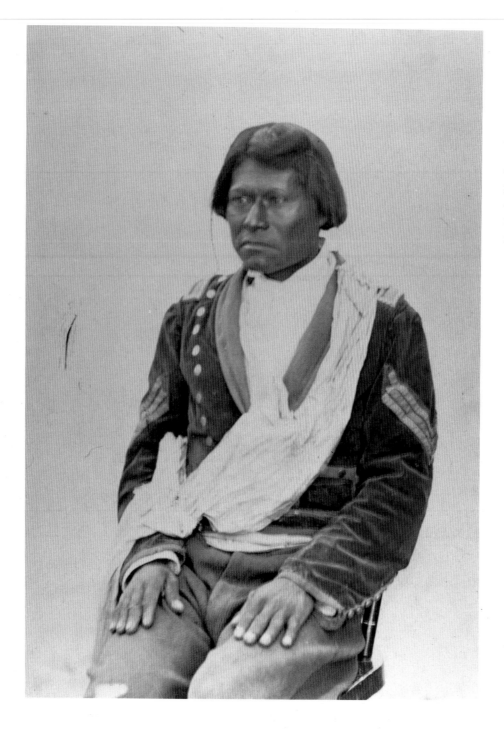

A Civil War photographer who documented almost every major battle of the war, Timothy O'Sullivan explored the continent with several geological surveys. Lugging glass plates on mule back over the mountains, he was adept at capturing the contour, contrast, and majesty of the landscape. O'Sullivan's portraits, unlike his landscapes, were often stiff and uncomfortable, as if everyone involved could hardly wait for the session to end.

Timothy O'Sullivan (1840–1882)
The King Expedition, Shoshone
1867
albumen print
9½" by 8½"

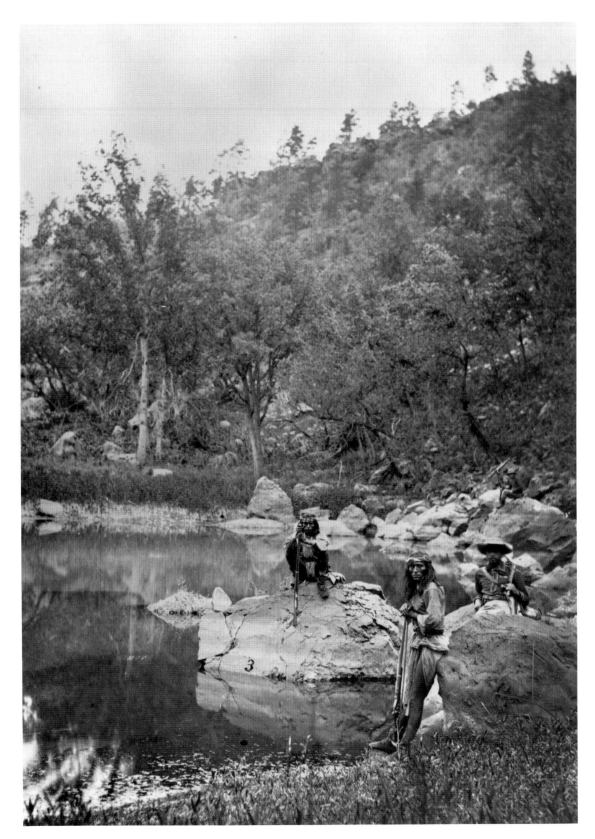

Timothy O'Sullivan (1840–1882)
View on Apache Lake, Sierra Blanca Range,
Arizona
1873
8" by 10⅞"

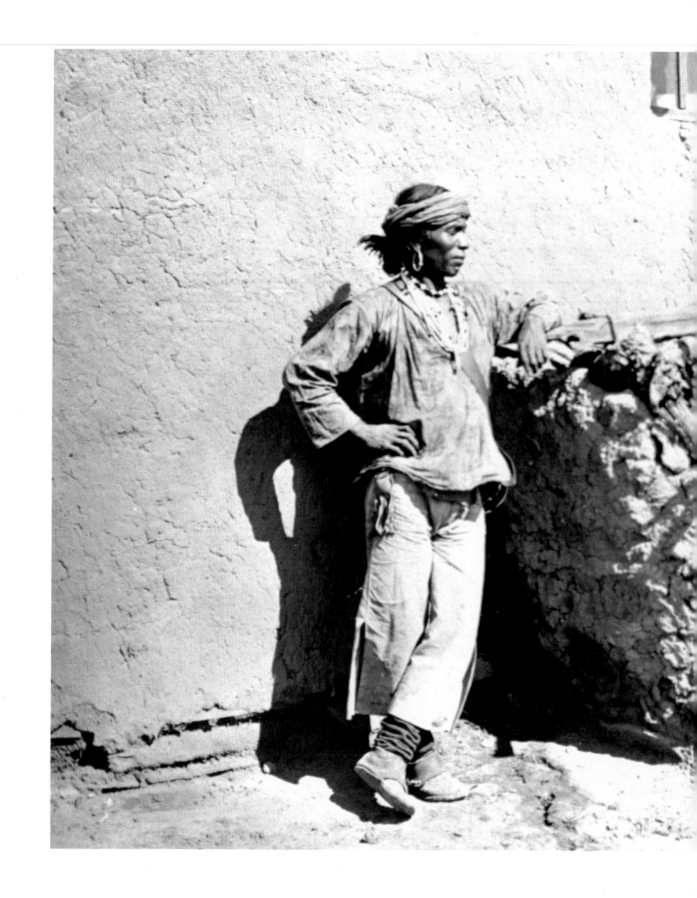

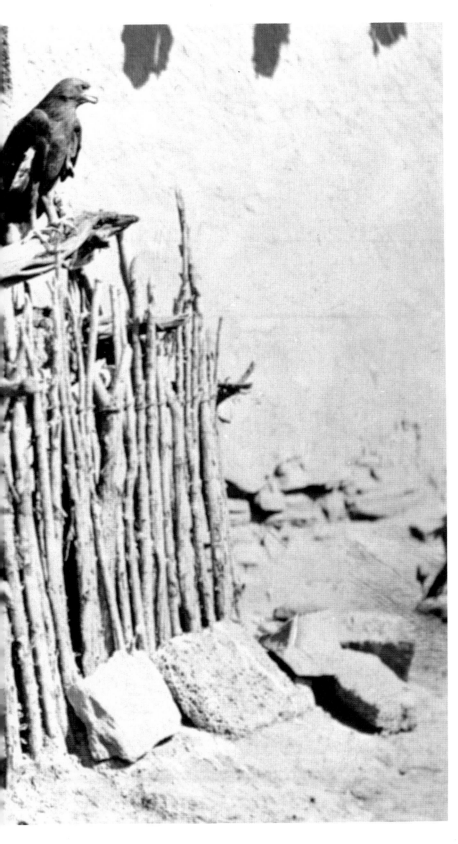

A German immigrant, John K. Hillers was a
Civil War soldier and a Brooklyn policeman
before he became a crewman—and later
official photographer—on John Wesley
Powell's expedition down the Colorado River.
A skilled portrait photographer, Hillers took
over twenty thousand pictures of Indians,
including the Ute Indians, who honored him
with the name Myself-in-the-Water. To his
colleagues on the expedition, he was known
as Jolly Jack.

John K. Hillers (1843–1925)
A Zuni Eagle Cage
1879
albumen print
9¼" by 7¼"

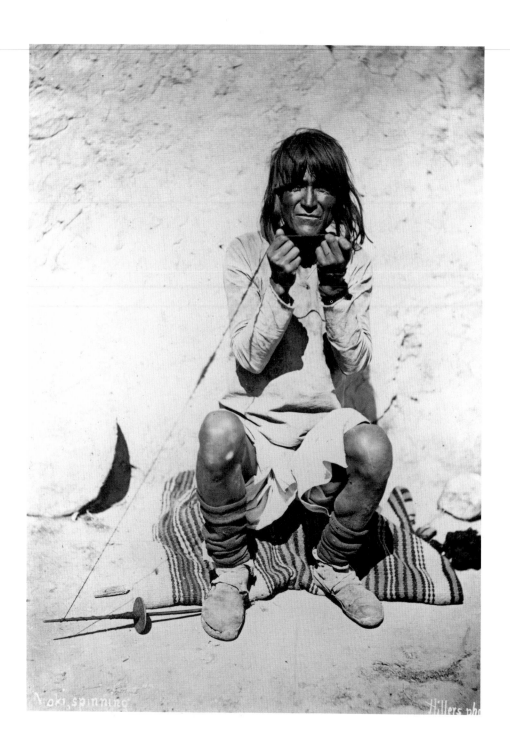

John K. Hillers (1843–1925)
A Moki, Spinning
1870s
albumen print
7¼" by 9³⁄₁₆"

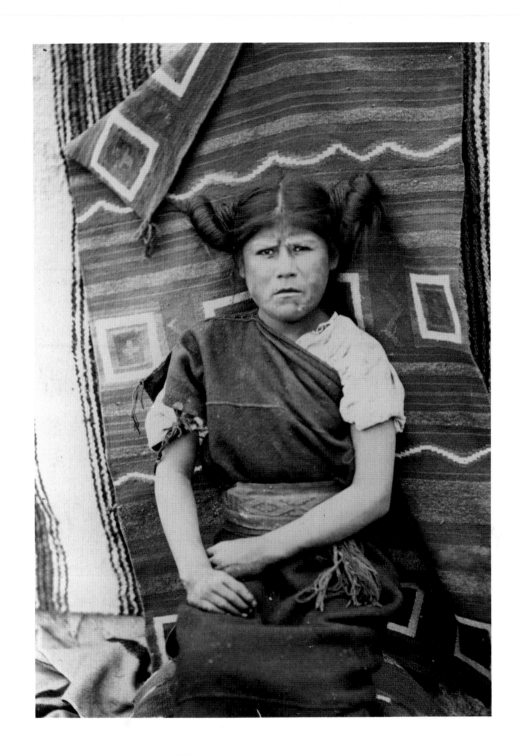

John K. Hillers (1843–1925)
Moki Girl
1879
albumen print
7¼" by 9"

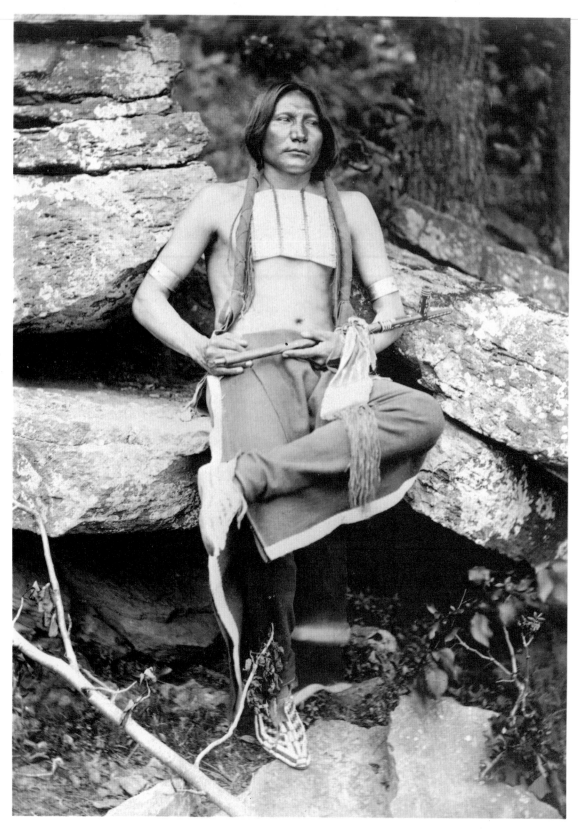

John K. Hillers (1843–1925)
Mok-Ka-No-Ints
1871
albumen print
7½" by 9⅜"

Although the aims of the expedition photographers were ethnographic, they nonetheless asked one Indian after another to pose in similar ways, hold identical objects, and even wear clothing not necessarily of the appropriate tribe.

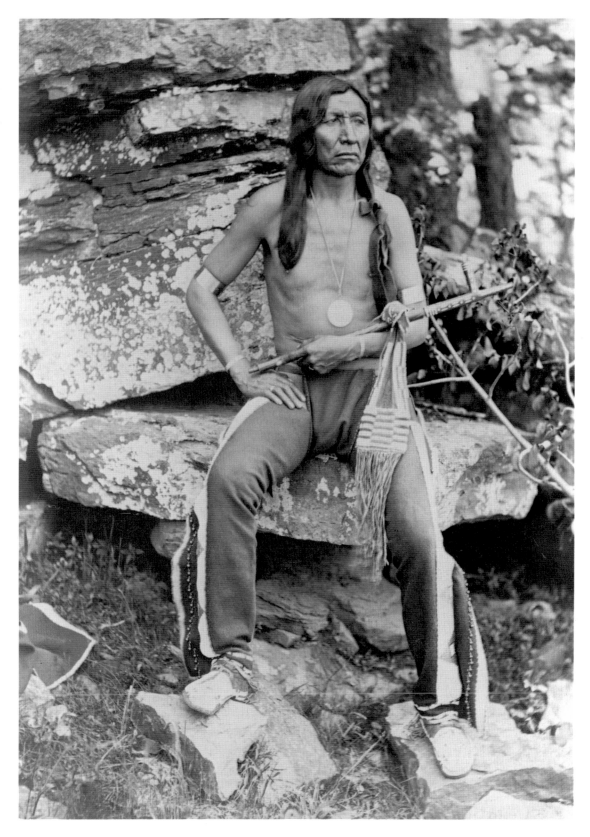

John K. Hillers (1843–1925)
Untitled
date unknown
7¹⁄₈" by 9¹⁄₂"

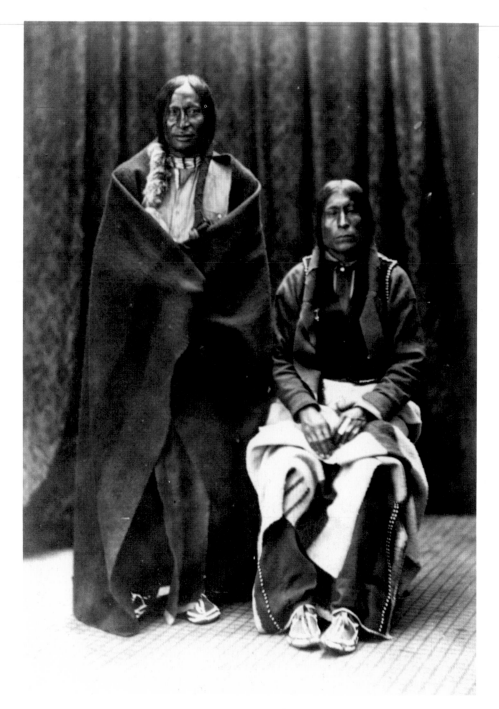

This picture, possibly of two Arapahoe Indians, was taken while Jackson was a member of the Hayden Expedition.

William Henry Jackson (1843–1942)
Untitled
1873
5¼" by 7¼"

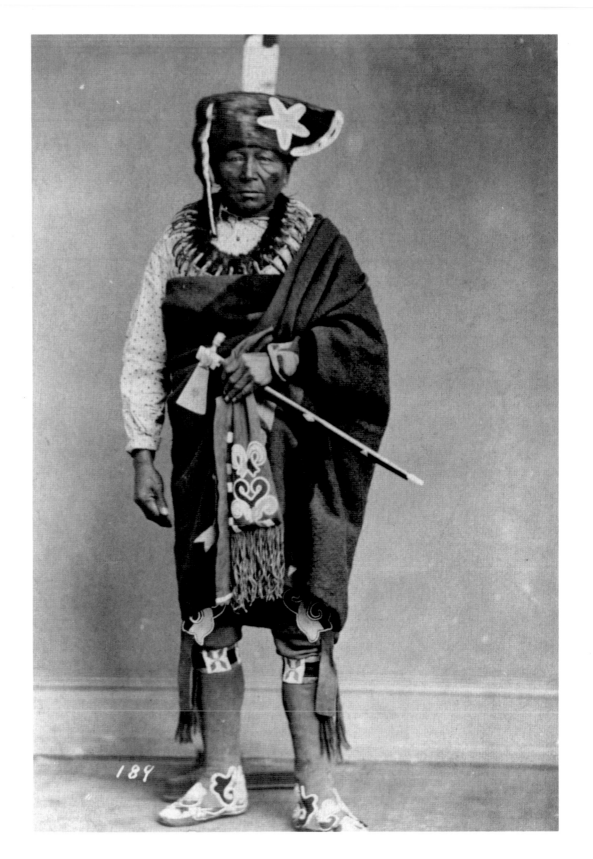

William Henry Jackson (1843–1942)
Untitled
date unknown
5¼" by 7¼"

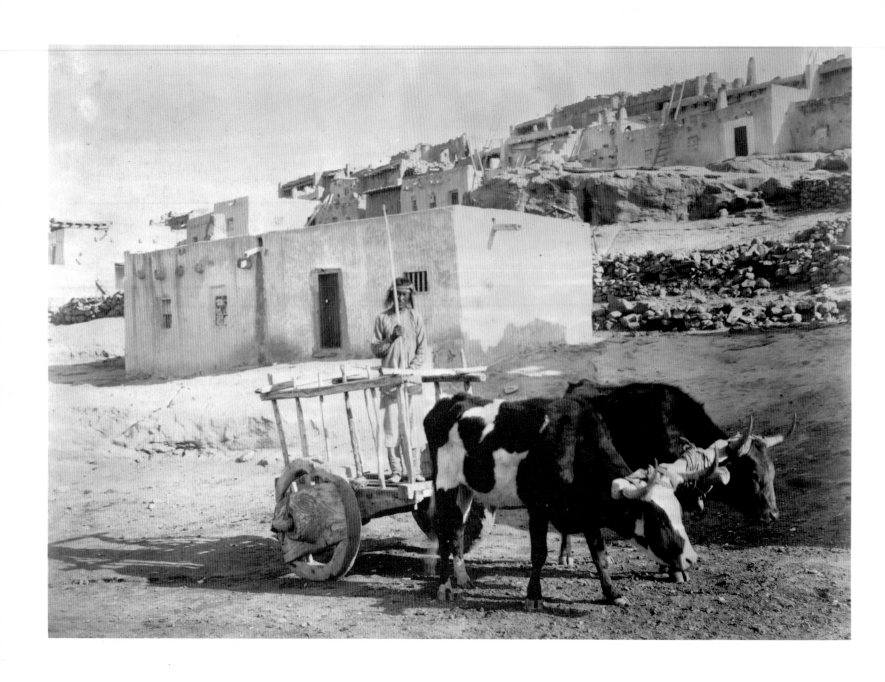

William Henry Jackson (1843–1942)
The Old Carreta, Laguna, N.M.
1870s
albumen print
21" by 17"

"*Portrait photography never had any charms for me,*" wrote William Henry Jackson. His true curiosity was geographic; he was celebrated for his dramatic landscapes, especially of Yellowstone. When he photographed Indians, he was not always successful at overcoming the resistance with which they often greeted the process. Skilled at self-promotion, Jackson turned thousands of photographs into hand-tinted postcards and was, in consequence, dubbed the "father of the picture postcard."

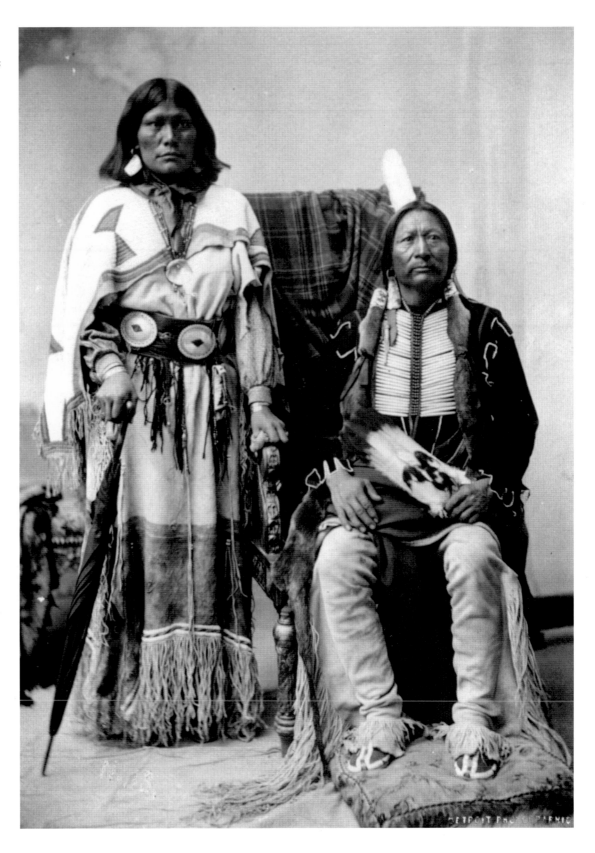

William Henry Jackson (1843–1942)
Utes, Buckskin Charlie and Squaw
date unknown
platinum print
7" by 9"

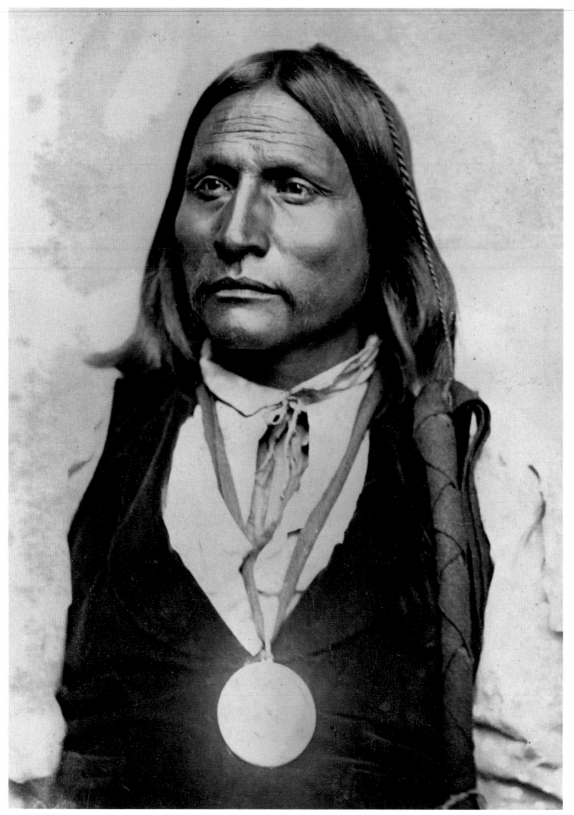

The Kiowa, a non-agricultural people forced to live on a reservation and raise corn, resisted the government's attempts to subdue them. In 1870, a group of Kiowa, including Big Bow, pictured here, and Chief Satanta, rode into Texas where they held up a wagon train and killed seven men. Afterwards, many of the Kiowa were imprisoned; with the extinction of the buffalo, their traditional way of life disappeared forever, and in 1878, Satanta committed suicide by jumping out of the window of a prison hospital in Texas.

William Henry Jackson (1843–1942)
Kiowa Chief Big Bow
date unknown
4" by 6"

Between 1880 and 1901, C. A. Nast operated a studio on Curtis Street in Denver, where he photographed the Ute Indians, including Buckskin Charlie, who is also shown on page 33 in a picture taken by William H. Jackson.

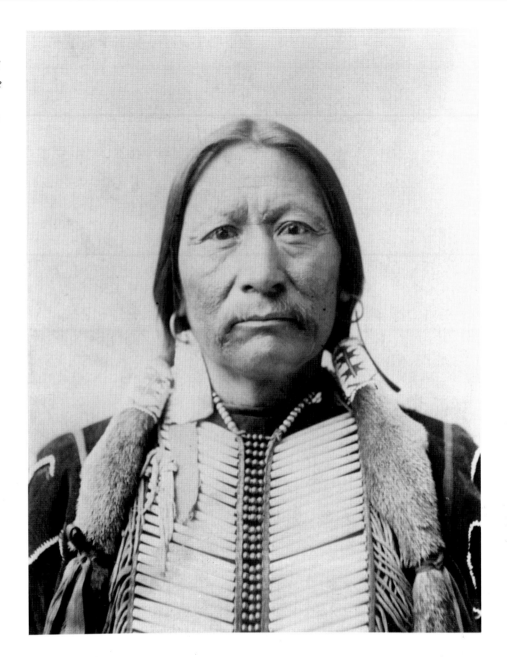

C. A. Nast
Buckskin Charlie, Head Chief of the Utes
date unknown
6¼" by 8¼"

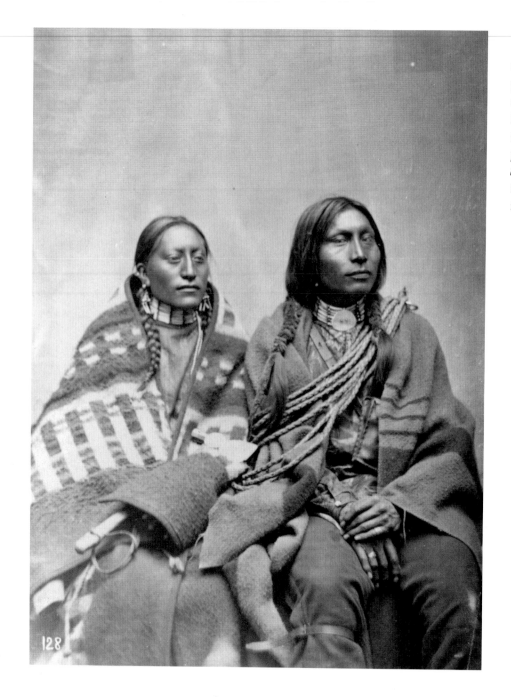

One of the better-known western photographers, Laton Huffman worked as a cattle wrangler and a railroad surveyor before he arrived at Fort Keogh, Montana, in 1878 to document military life. In his studio, he photographed both the soldiers and the Sioux and Cheyenne who were prisoners of war there. This couple may have been among those Indians.

Laton A. Huffman (1854–1931)
Man on the Hill and Wife
1879
4¾" by 6⅜"

A Hunkpapa Sioux, Gall was an orphan who was adopted by Sitting Bull as a younger brother. In the Battle of Little Big Horn in 1876, Gall played an important part. The reprisals were severe, however, and in 1877, he accompanied Sitting Bull into exile in Canada. After the harsh winter of 1880, Gall and many other Sioux returned to the reservation. This picture was probably taken after that.

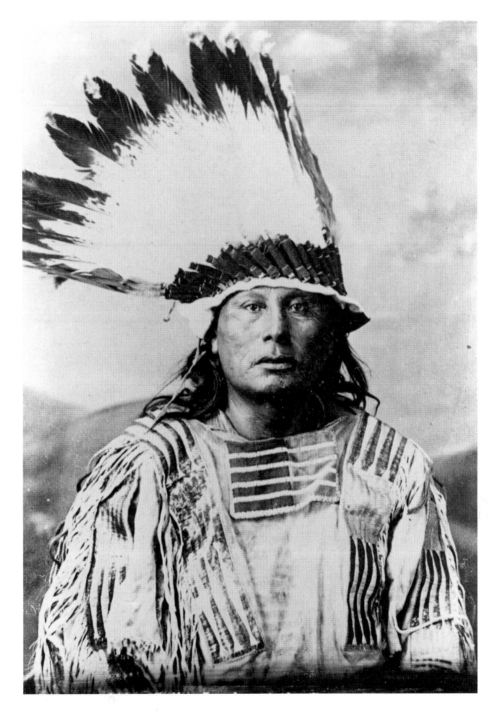

Laton A. Huffman (1854–1931)
*Gall, Leader at the Custer Massacre,
the Great Orator of the Sioux Nation*
date unknown
3⅞" by 5⁷⁄₁₆"

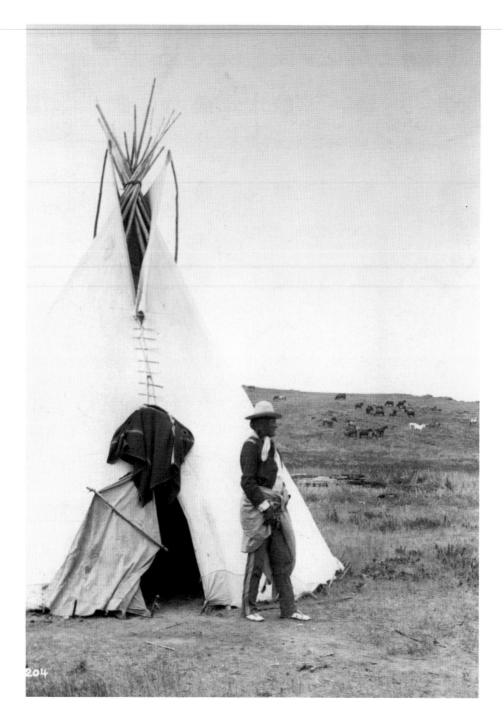

Lame Deer, American Horse was a Minneconjou Sioux and a supporter of Sitting Bull.

Laton A. Huffman (1854–1931)
Lame Deer, American Horse
1882
6¹⁄₂" by 8"

Although customs differed from tribe to tribe, marriage customs in general were more fluid among the Indians than among the whites. Trial marriage, serial marriage, polygamy, and homosexual marriage were accepted practices in many Native American cultures.

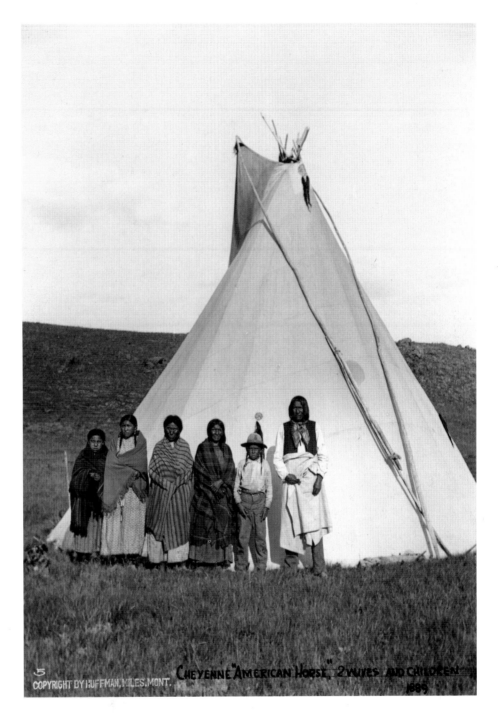

Laton A. Huffman (1854–1931)
Cheyenne American Horse, Two Wives and Children
1889
6" by 8"

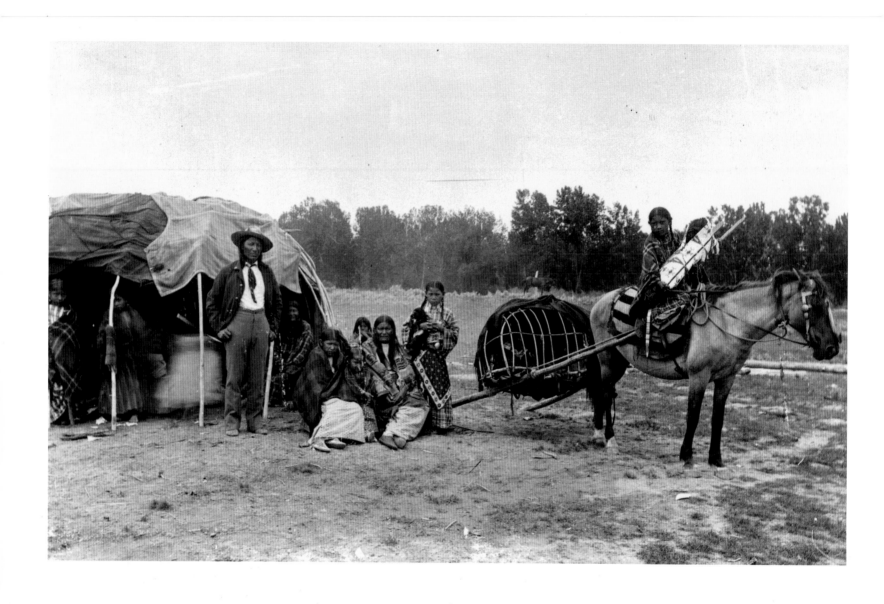

Christian Barthelmess (1854–1906)
Frank Stump Horn and Family
date unknown
6¼" by 4"

(left) After leaving his native Germany in the 1870s to escape conscription, Christian Barthelmess enlisted in the U.S. Army as a musician. Over the course of his long military career, he served in the Southwest, Colorado, and Montana. From 1888 to 1898, he was an official photographer at Fort Keogh, Montana, where he took pictures of the Cheyenne and the Crow.

(right) Although he originally emigrated to the United States from Scotland in order to establish a utopian community, Alexander Gardner quickly gave that up in favor of photography. A Civil War and railroad photographer, he is best known for the gallery he ran in Washington, D.C., where he took pictures of Indians who came east as delegates.

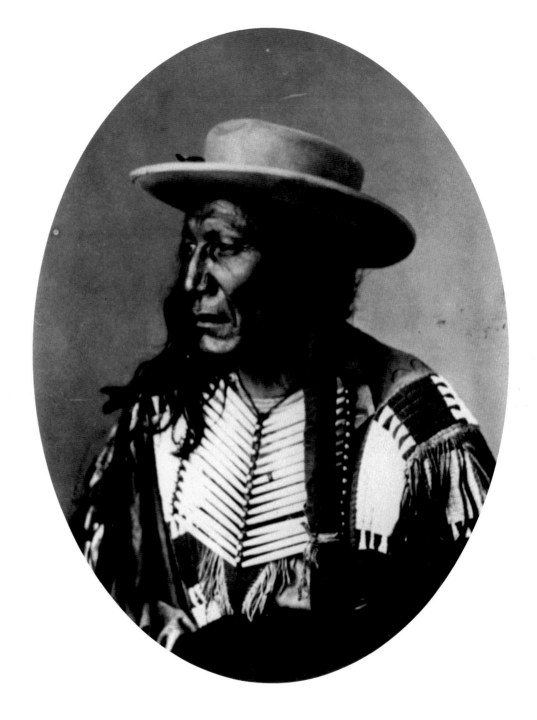

Alexander Gardner (1821–1882)
*Tchan-Gm-Ani-Tah-An Ka-Ti-Ah
(High Wolf)*
date unknown
albumen print
5¼" by 3⅜"

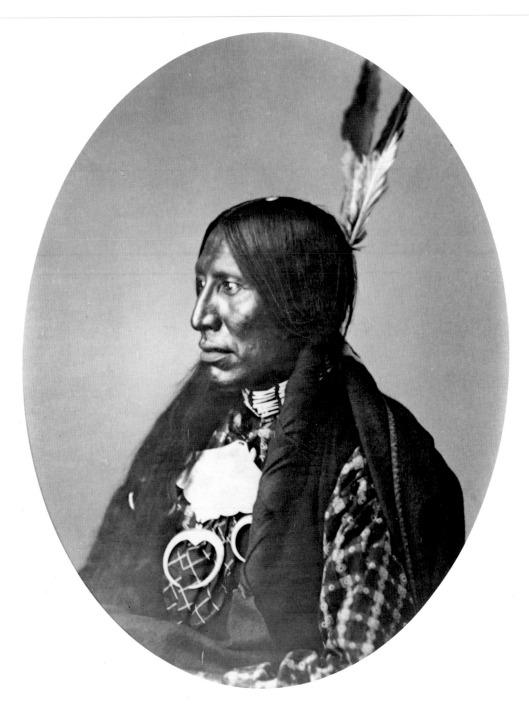

Alexander Gardner (1821–1882)
*Vua-Lluh-Ko-Ke-Pah (One Afraid
of the Eagle)*
date unknown
4" by 5¼"

Bailey, Dix, and Mead, active in the Dakota Territory during the 1880s, are best known for their pictures of Sitting Bull and his associates. This portrait was probably taken at Fort Randall, where Sitting Bull and a band of his supporters were imprisoned after spending four years in Canada. When the Canadian government denied them sanctuary, they were promised amnesty by the United States. Upon their return, that promise was broken.

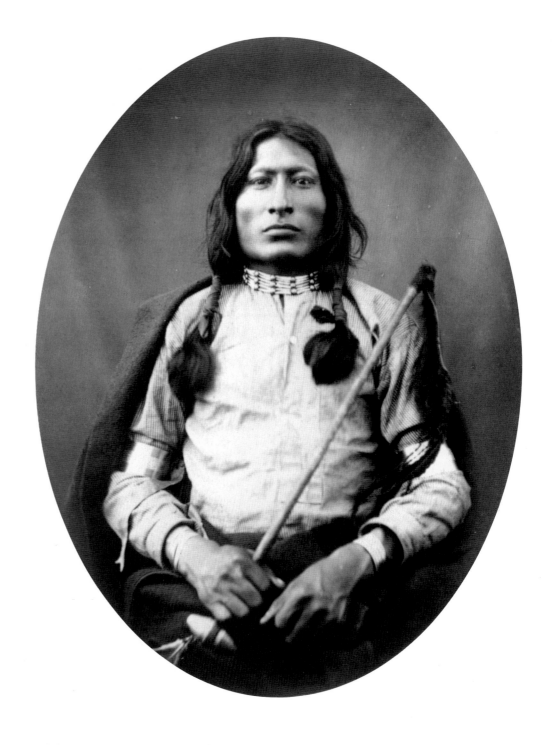

Bailey, Dix, and Mead
Untitled
1882
4" by 6"

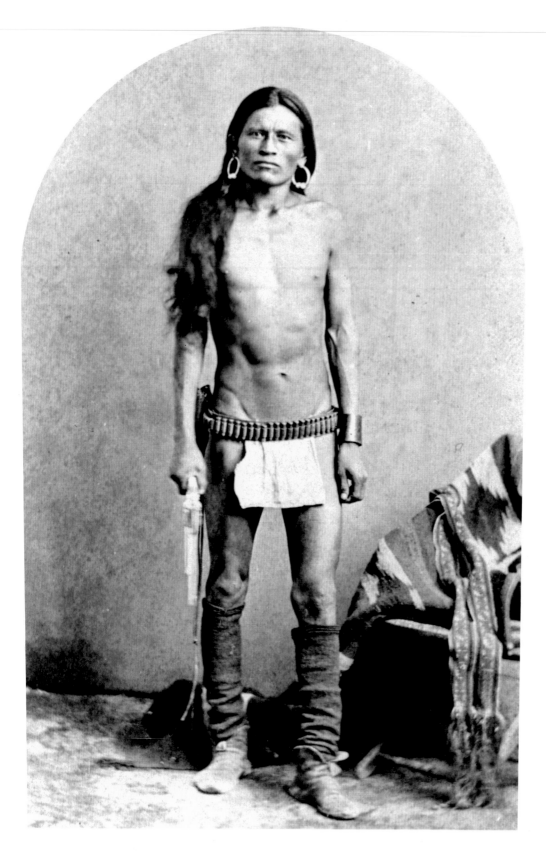

Ben Wittick (1845–1903)
"Charlie," Navajo Scout with Lieutenant Wright
date unknown
cabinet card
4" by 7"

Ben Wittick was a photographer for the Atlantic and Pacific Railroad, and later for the Atchison, Topeka, and Santa Fe. In 1880, he opened a gallery in Albuquerque. Fascinated by the Hopi Snake Dance, he was one of the few white men to see the most secret part of that sacred ceremony. It captivated him so much that he couldn't stay away, even after a tribal elder predicted he would die of snakebite—a prophecy that was fulfilled twenty years later.

Cabinet cards were invented in 1866 to replace the waning craze for exchanging the smaller cartes de visite. These cards, published by Wittick and his partner R. W. Russell, were 4 by 7 inches, a size introduced in 1875 and known as the "Promenade" style. Longer and narrower than previous cards, they were intended to show standing figures. Throughout the 1880s, cabinet cards were sought-after items. Pictures of Indians were popular, as were photographs of celebrities including President James Garfield, whose image was in great demand after his assassination in 1881.

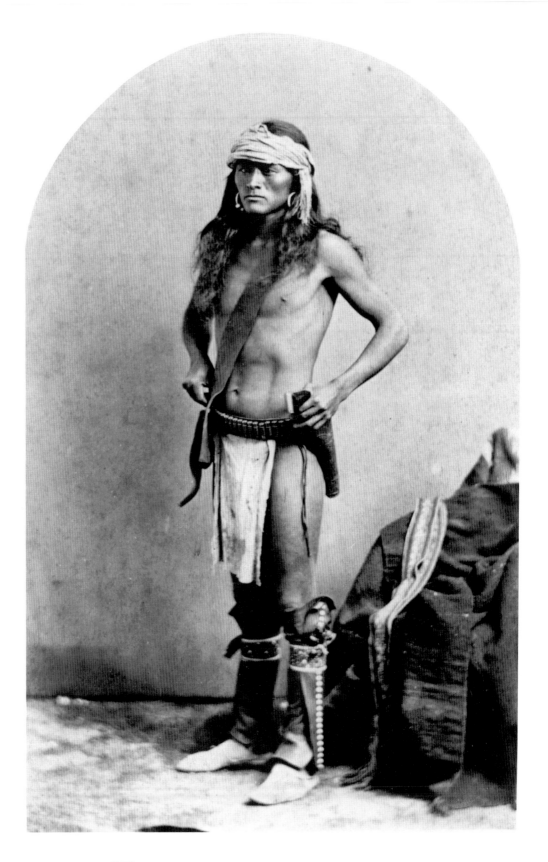

Ben Wittick (1845–1903)
Navajo Scout
date unknown
cabinet card
4" by 7"

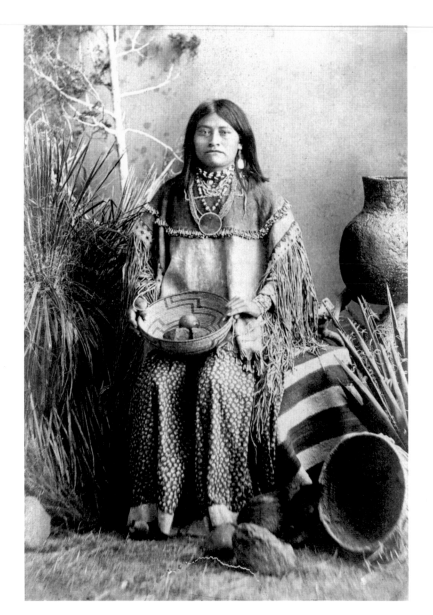

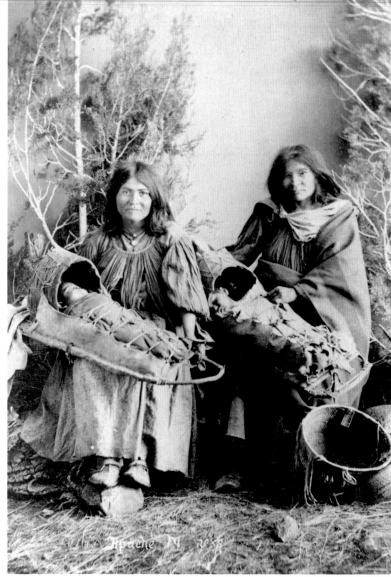

Unidentified Photographer
Daisy
date unknown
4⁹⁄₁₆" by 7¼"

Unidentified Photographer
Apache Mothers: Two Apache Mothers
with Babies
date unknown
4½" by 7¼"

(right) Peaches, in the center, led General Crook into Mexico on his search for Geronimo in the 1880s. He was called on again by the U.S. government in 1916, this time to help General Pershing in his unsuccessful hunt for Pancho Villa.

The similarity of props in these standard studio images suggests that they were taken in the same photographic gallery, probably in the 1880s.

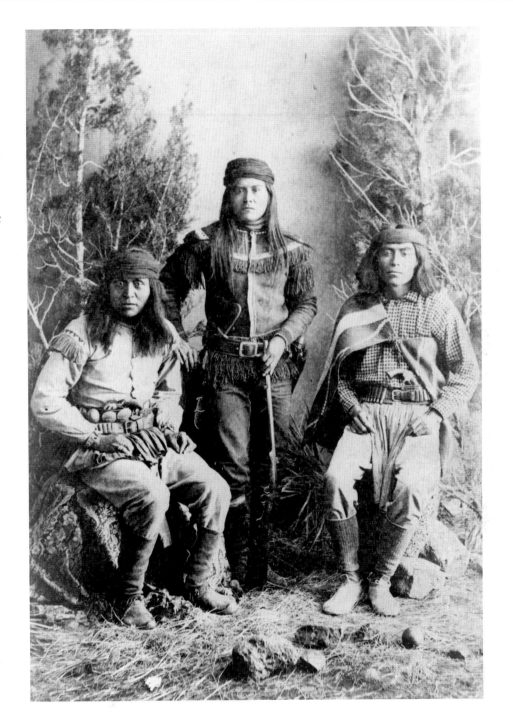

Unidentified Photographer
Peaches, Crook's Guide into Mexico, with Apache Scouts
date unknown
4¹/₂" by 7¹/₄"

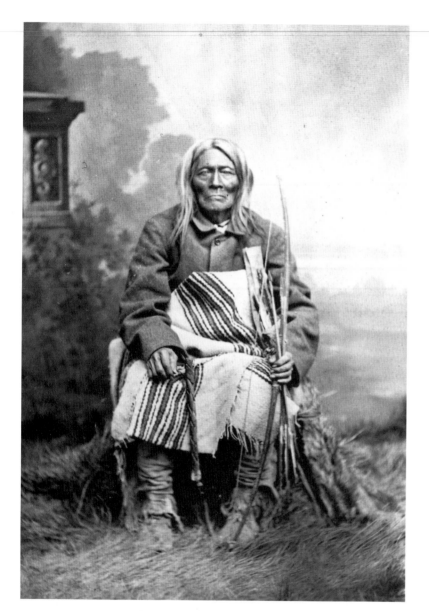

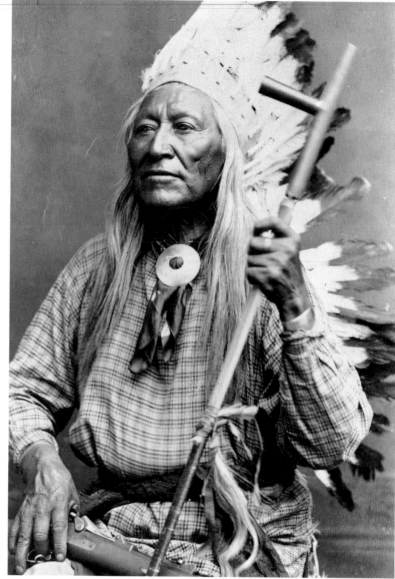

Unidentified Photographer
Indiens de l'Arizona
date unknown
3⁷⁄₈" by 5½"

Unidentified Photographer
Indiens de l'Arizona
date unknown
4" by 6½"

These three pictures are collectively entitled Indiens de l'Arizona. *The young man with the gun and the loincloth appears to be a White Mountain Apache.*

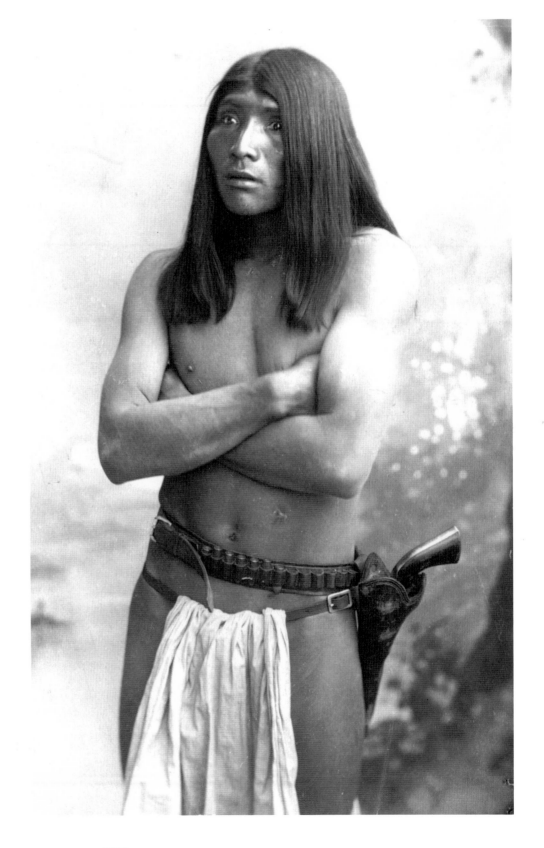

Unidentified Photographer
Indiens de l'Arizona
date unknown
4" by 6½"

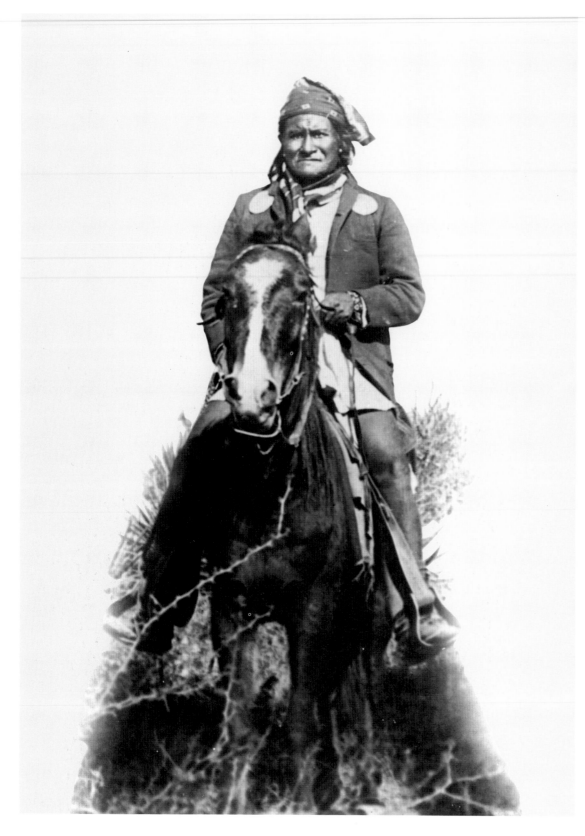

Camillus S. Fly of Tombstone, Arizona, accompanied Gen. George Crook into Mexico to photograph Geronimo. When his pictures were published in Harper's Weekly, Fly became well known. A yellowed piece of paper on the back of this photograph reveals the white attitude towards the Indians. It reads in part: "Geronimo, The Apache Chief, as taken before the surrender to Gen. Crook in the Sierra Madre Mountains of Mexico. Escaped March 30, 1886. The most fiendish, cruel, and bloodthirsty of the Apaches now defying the United States and Mexico."

Camillus S. Fly (1849–1901)
Geronimo
1886
5" by 7⅞"

"No Indian that ever lived loved the white man," Sitting Bull once said. *"And no white man that ever lived loved the Indian."* This tremendously sad picture was taken by a photographer working out of Yankton, South Dakota.

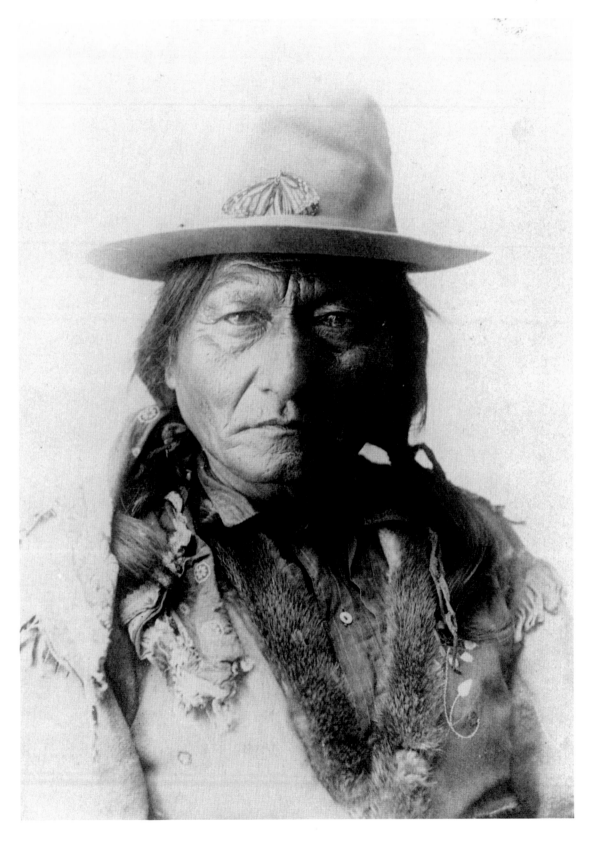

George W. Scott
Sitting Bull
1880s
albumen print
4" by 5½"

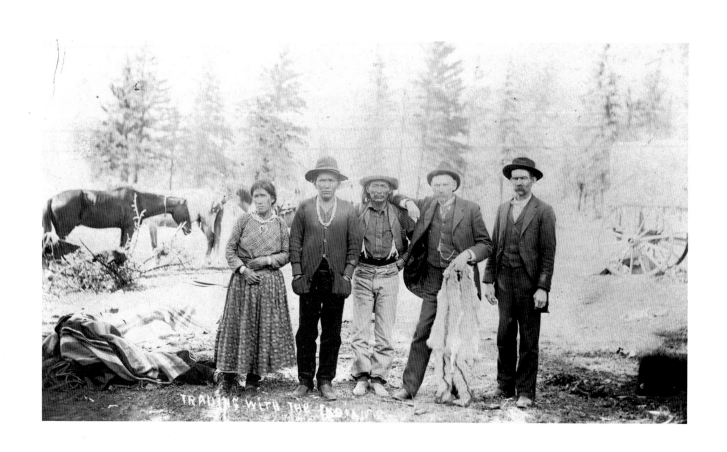

E. E. Glew
Trading with the Indians
date unknown
cabinet card
7½" by 4½"

(left) A curious addendum to this unsettling image is provided on the back of this cabinet card, on which Colorado dealer H. W. Wyman advertises his goods and services: "Watches, Diamonds, Fine Jewelry, Solid Silver Novelties, Silver-Plated Ware, Cut Glass, Canes and Umbrellas—Carved and Burned Leather Goods. Navajo Blankets, Indian and Mexican Pottery. Minerals, Agate Goods, Turquoise and Opals, Linen Drawn Work…Indian Baskets. Birds and Animals Mounted to Order. Fine Watch Repairing. Eyes Correctly Fitted."

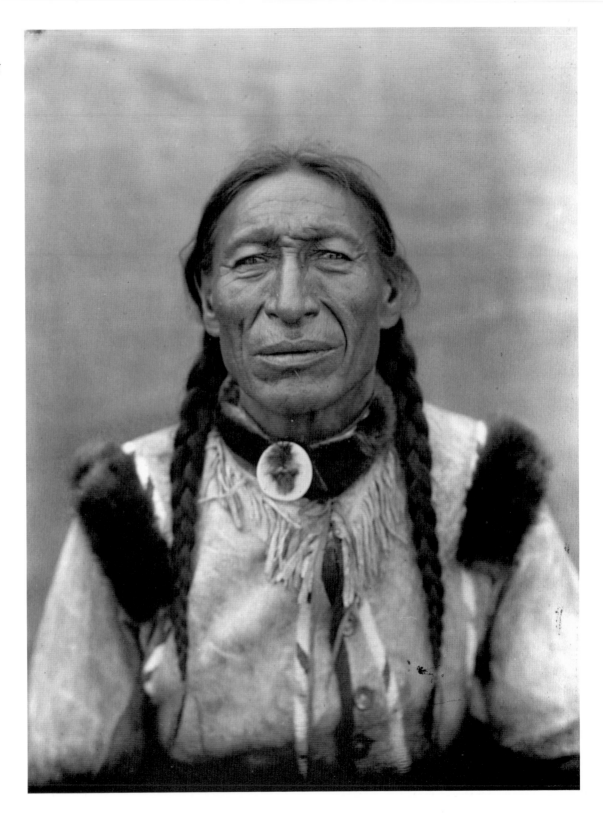

Unidentified Photographer
Iron Tail
date unknown
7¼" by 9"

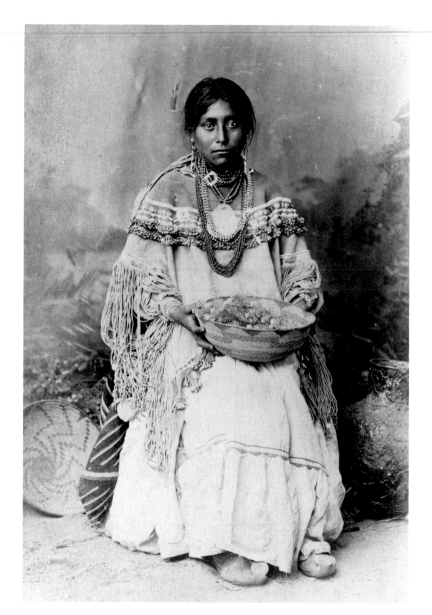

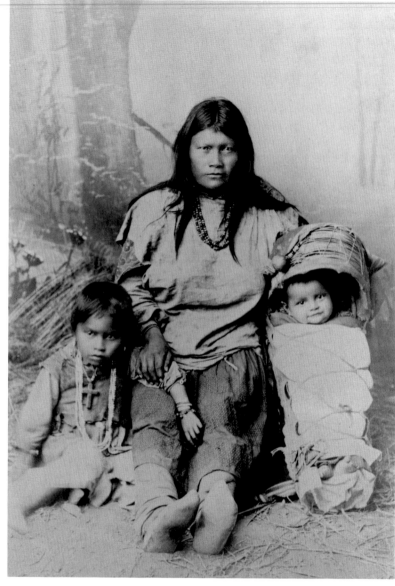

Unidentified Photographer
American Indian
July 9, 1884
$4^{1}/_{2}$" by $7^{5}/_{8}$"

Unidentified Photographer
Untitled
July 9, 1884
4" by $7^{1}/_{4}$"

These three pictures, printed in the seaside town of Barmouth, Wales, attest to the European interest in Native Americans. The man in this photograph, possibly an eastern Apache or a Ute, is wearing a presidential peace medal.

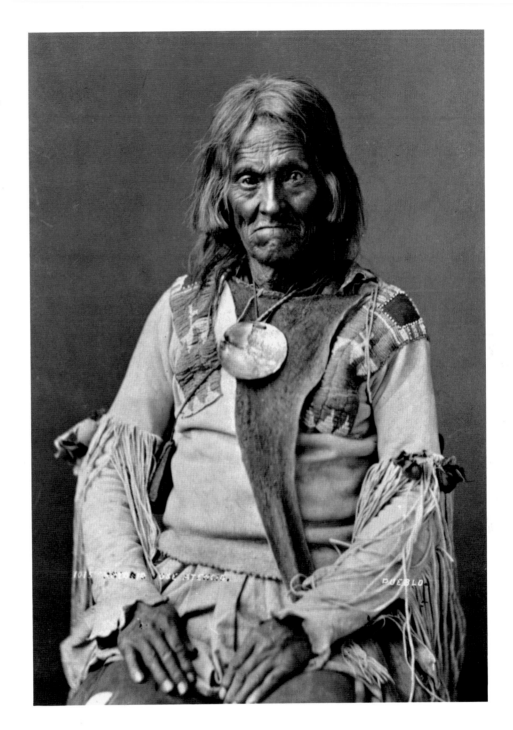

Unidentified Photographer
Untitled
1884
5" by 7½"

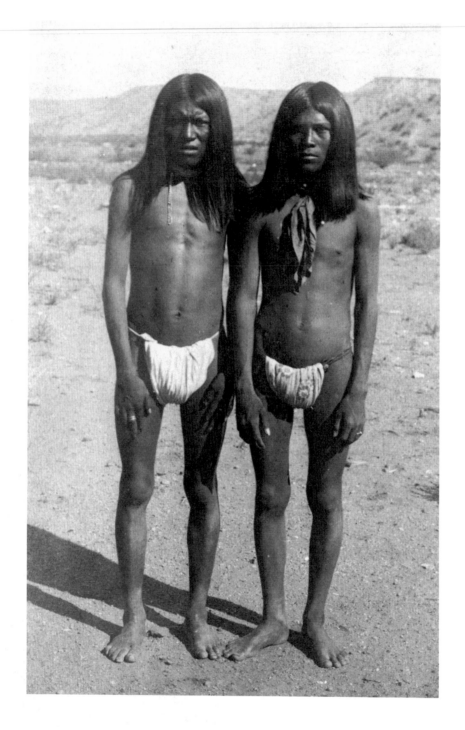

A. Frank Randall
Untitled
date unknown
5¼" by 8½"

A. Frank Randall worked in the Arizona Territory during the 1880s and also accompanied General Crook into Mexico on his search for Geronimo. These pictures were taken at the San Carlos Reservation. Problems of attribution arise, however; Randall copied the work of other photographers, including Ben Wittick, and his original photographs were in turn copyrighted by others, including Wittick, Henry Buehman, and A. Miller.

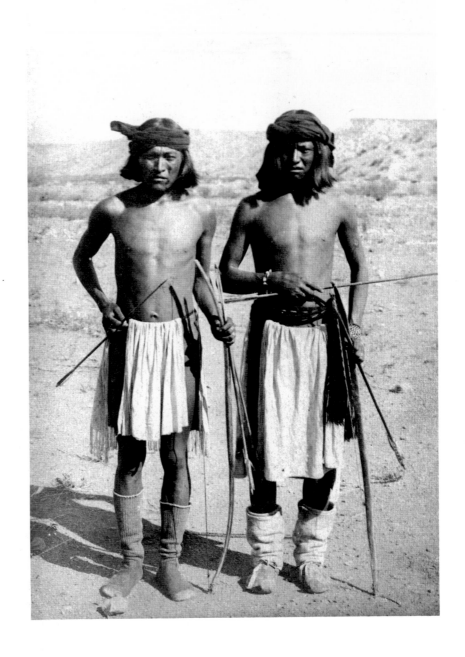

A. Frank Randall
White Mountain Apaches
date unknown
5¼" by 8½"

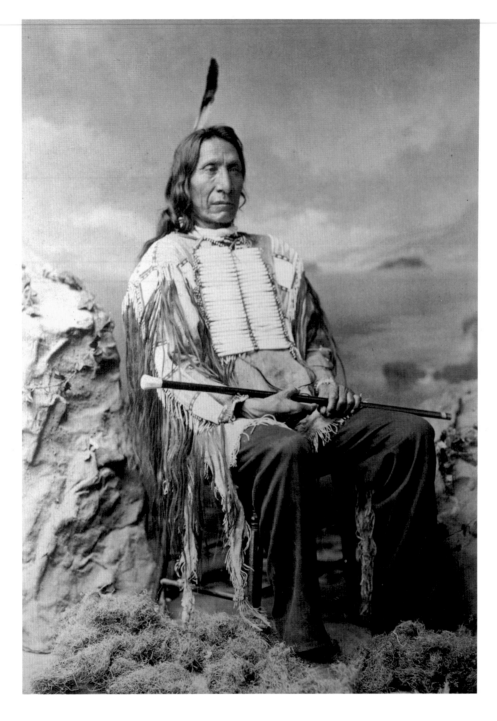

(left) Chief Red Cloud was an able warrior and an adept negotiator who won a major victory against the United States in 1868, as a result of which the U.S. army was forced to abandon the Bozeman Trail. When he met with President Grant after the Civil War, he and the other members of the Sioux delegation, clad in white men's clothing, were invited by Mathew Brady to be photographed. On that occasion, as on many others, Red Cloud declined, stating, "I am not a white man, but a Sioux." A picture of his son, Jack Red Cloud, is on page 67.

(right) Charles M. Bell was a Washington, D.C., photographer who worked with his father and brothers in a studio on Pennsylvania Avenue. This picture was taken in 1891, after the devastating battle at Wounded Knee. The members of the delegation, numbered beneath the photograph, include High Hawk (1), Hump (6), Little Wound (7), American Horse (12), Young-Man-Afraid-of-His-Horses (13), and John Shangrau (17), a half-breed scout.

Charles Milton Bell (1848–1893)
Red Cloud, Dakota Sioux
1880
9¾" by 16"

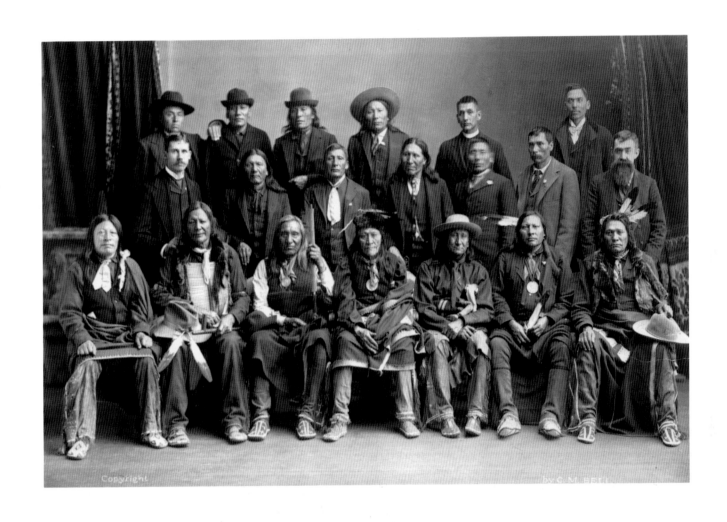

Charles Milton Bell (1848–1893)
Sioux Delegation to Washington, D.C.
1891
albumen print
21" by 14¼"

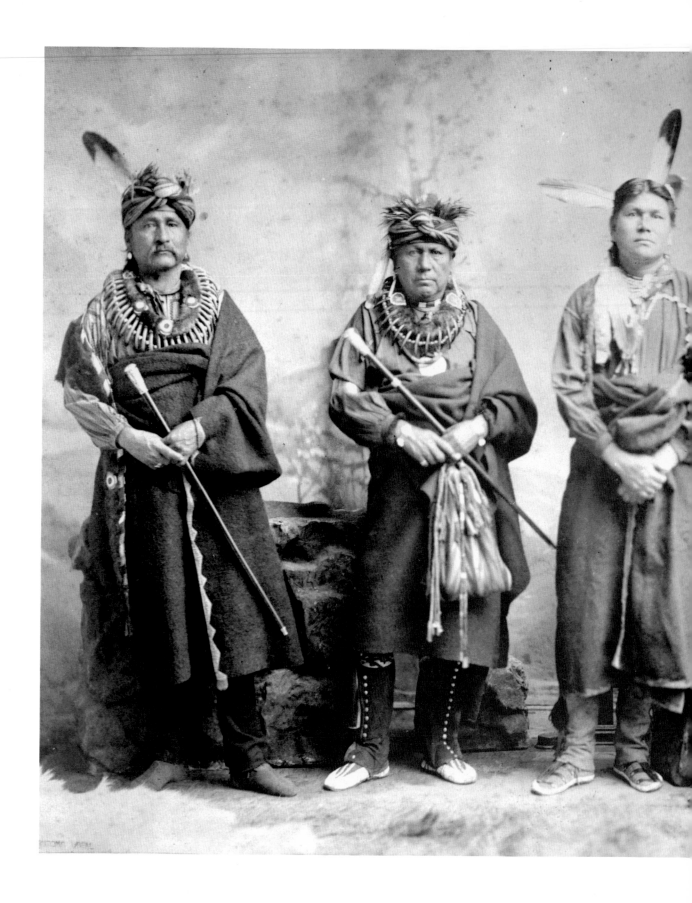

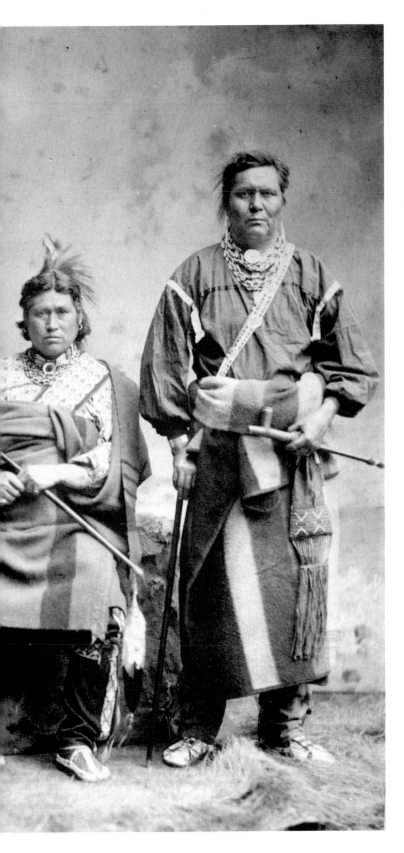

Originally gatherers of wild rice in what is now Wisconsin, the Fox Indians fought against the French, were pushed by the Ojibwa into the lower part of the state, and, despite organized resistance, ended up in Iowa where members of the Illinois militia shot at them—children too—to keep them west of the Mississippi. In this photograph, four members of the delegation to Washington, D.C., are standing while Chief On On A Wat (Can't Do It) remains seated.

Charles Milton Bell (1848–1893)
The Fox Indians
1890
albumen print
20⅞" by 15"

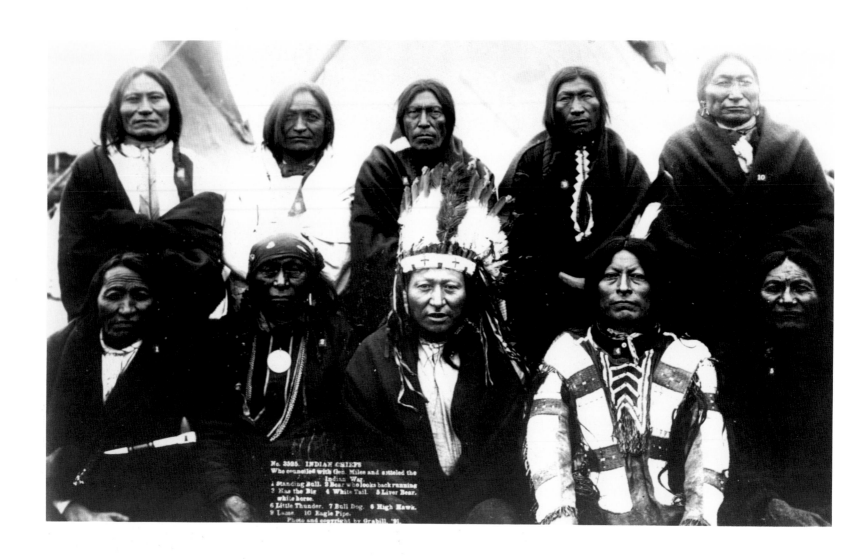

John C. H. Grabill
Indian Chiefs Council with General Miles
1891
7³⁄₈″ by 4³⁄₈″

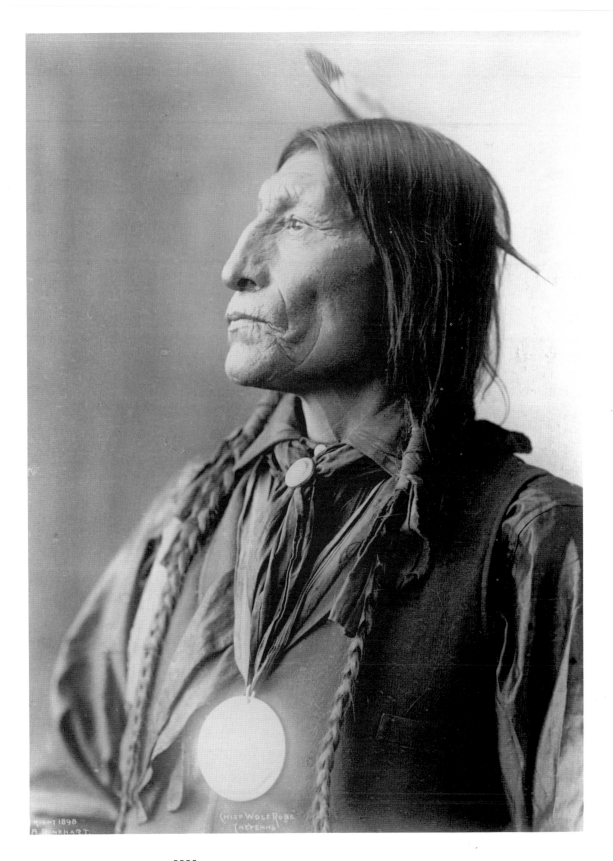

Frank A. Rinehart (1862–1928)
Chief Wolf Robe, Cheyenne
1898
7″ by 9″

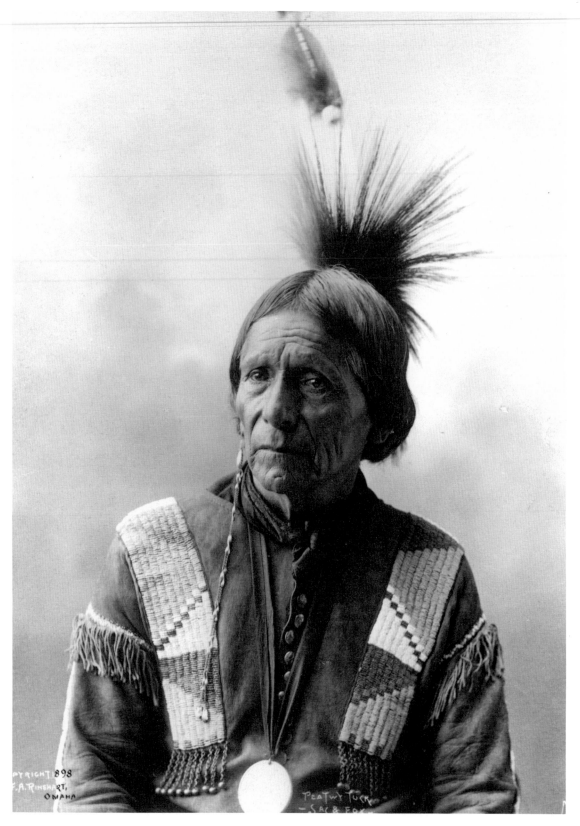

The Sac and Fox Indians were Algonquin-speaking tribes who allied themselves from 1733 to approximately 1850 in order to negotiate with the U.S. government as a single body.

Frank A. Rinehart (1862–1928)
Peatwy Tuck, Sac & Fox
1898
7⅛″ by 9½″

In 1898, Frank Rinehart was official photographer of the Trans-Mississippi and International Exposition in Omaha, Nebraska. Five hundred Indians, representing groups from around the country, attended. In addition to some traditional feasts and dances, mock battles were staged; President William McKinley viewed one of them. During the last week of the exposition, Rinehart was asked to photograph the Indians. Although in many cases, his assistant, Adolph F. Muhr, probably took the pictures, they were copyrighted in Rinehart's name.

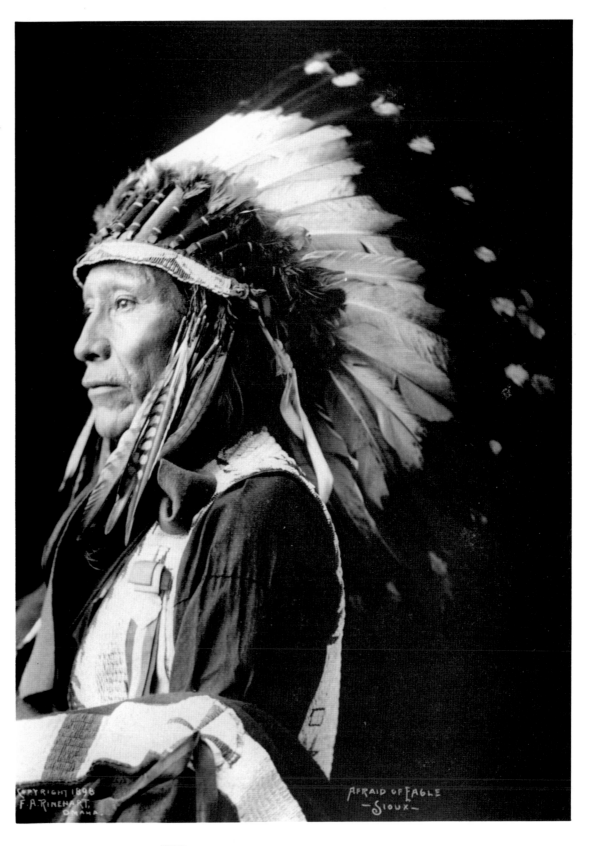

Frank A. Rinehart (1862–1928)
Afraid of Eagle, Sioux
1898
7" by 9"

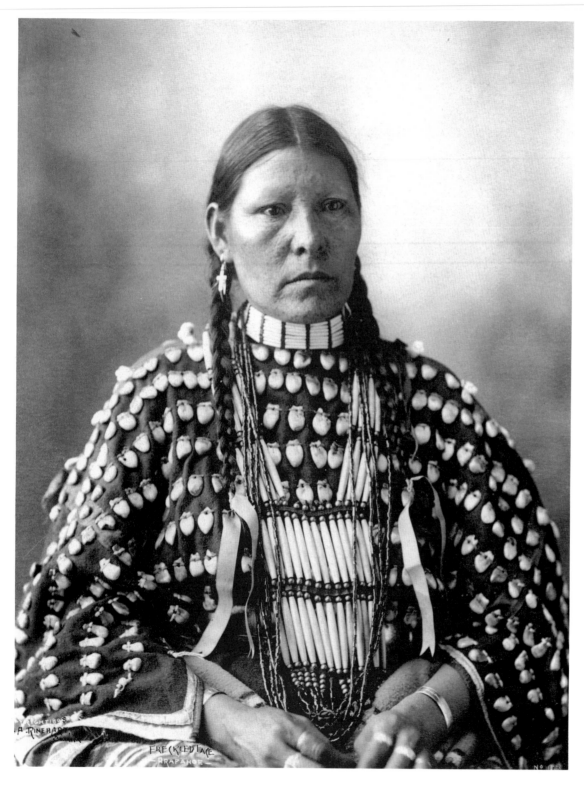

Frank A. Rinehart (1862–1928)
Freckled Face, Arapahoe
1898
7" by 9"

Jack Red Cloud was the son of the great Sioux leader Chief Red Cloud, whose picture is on page 58.

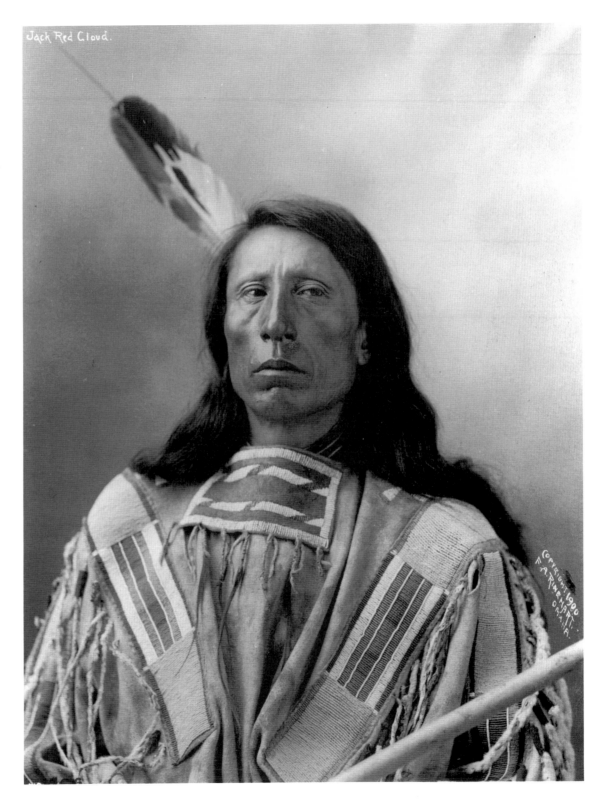

Frank A. Rinehart (1862–1928)
Jack Red Cloud
1900
6¾" by 8¾"

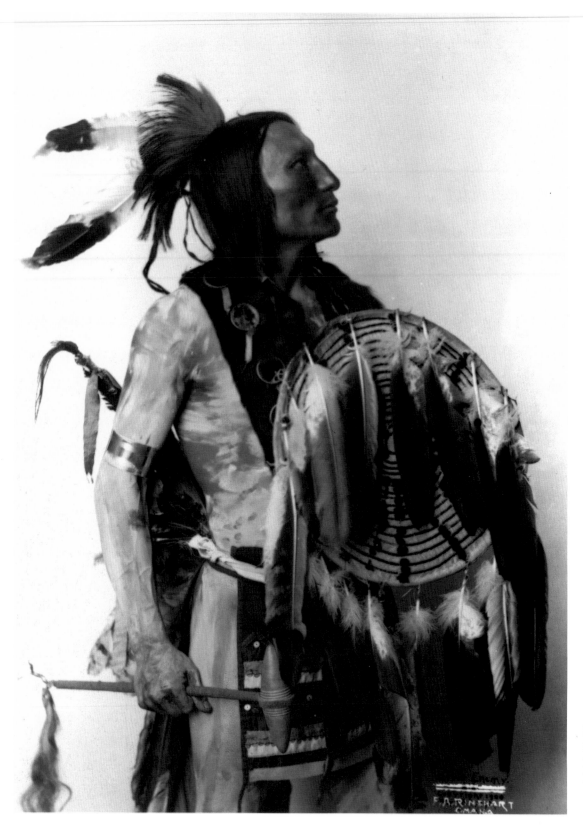

Frank A. Rinehart (1862–1928)
Chief Goes to War, Sioux
1898
11½″ by 15″

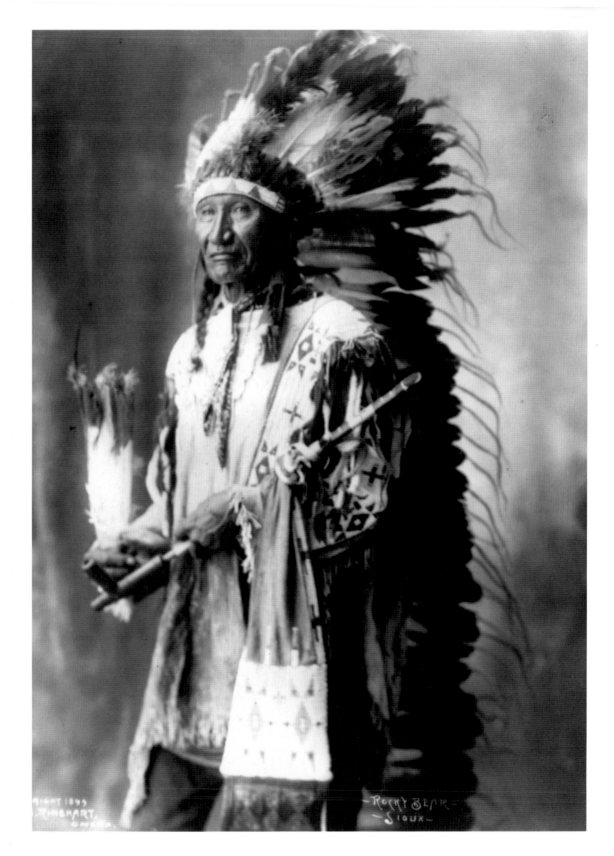

Frank A. Rinehart (1862–1928)
Rocky Bear, Sioux
1899
11³⁄₈″ by 15″

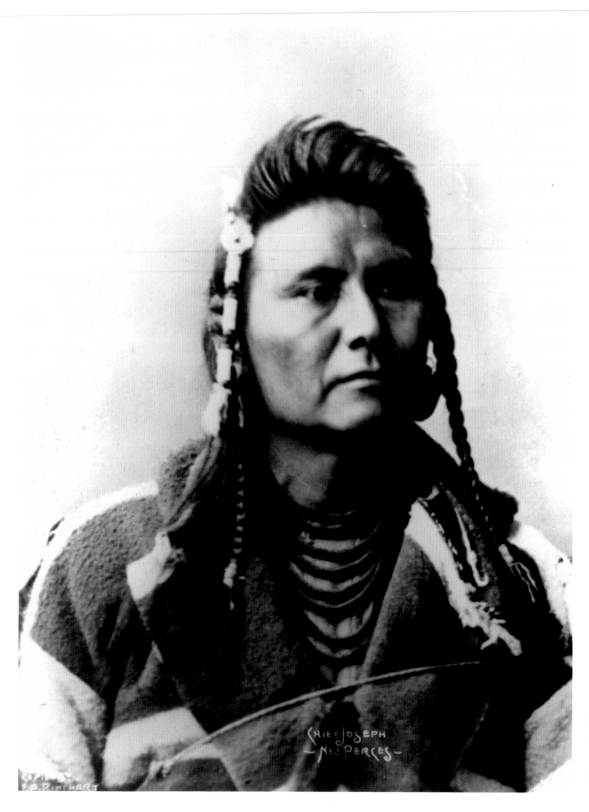

Chief Joseph (1840–1904) of the Nez Percé, displaced from his land after gold was discovered there, spent his life in a futile attempt to return. In 1877, hostilities escalated. When Joseph surrendered after months of bloodshed, he made what is perhaps the most famous speech of the Indian Wars: "…Hear me, my chiefs! I am tired; my heart is sick and sad. From where the sun now stands I will fight no more forever." Rinehart may not have taken this picture; it may be a copy of a photograph made by someone else.

Frank A. Rinehart (1862–1928)
Chief Joseph, Nez Percés
1898
silver print
11½" by 15"

Black Bear was an important chief of the Northern Arapahoe. Although on the front this picture is copyrighted by Heyn Photo of Omaha, on the back it is attributed to Rinehart and Heyn. The likelihood is that Rinehart took the picture.

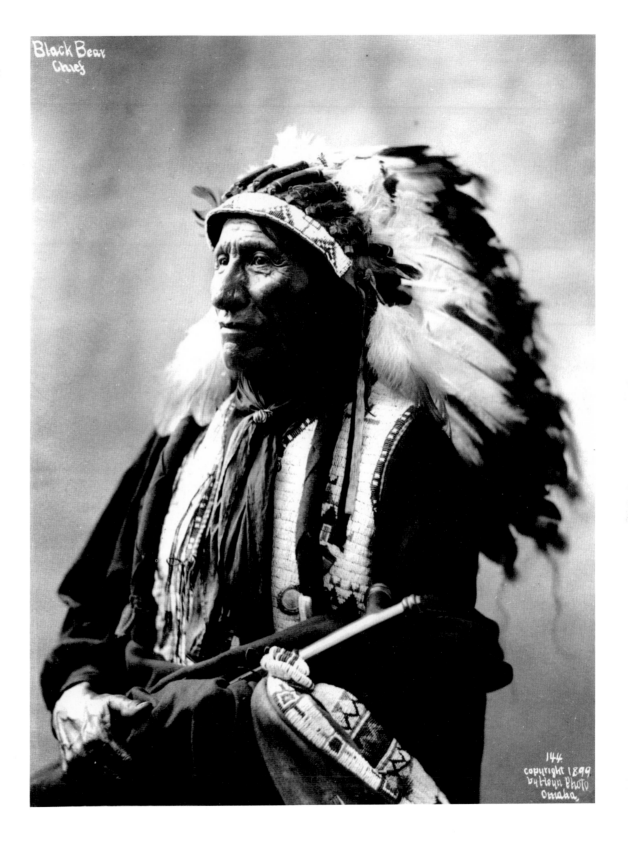

Frank A. Rinehart (1862–1928)
Black Bear, Chief
1899
6¾″ by 8¾″

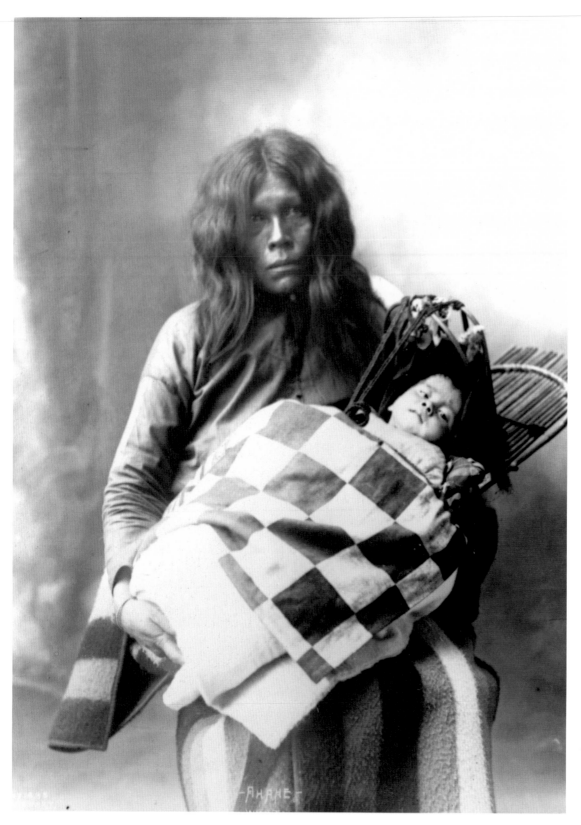

Frank A. Rinehart (1862–1928)
Ahaha, Wichita
1898
11½″ by 15″

From 1881 to 1915, six members of the Heyn family were working photographers. They were active in Omaha at the time of the Trans-Mississippi and International Exhibition, where this picture was probably taken, either by Herman (born in Germany in 1852) or Sabina.

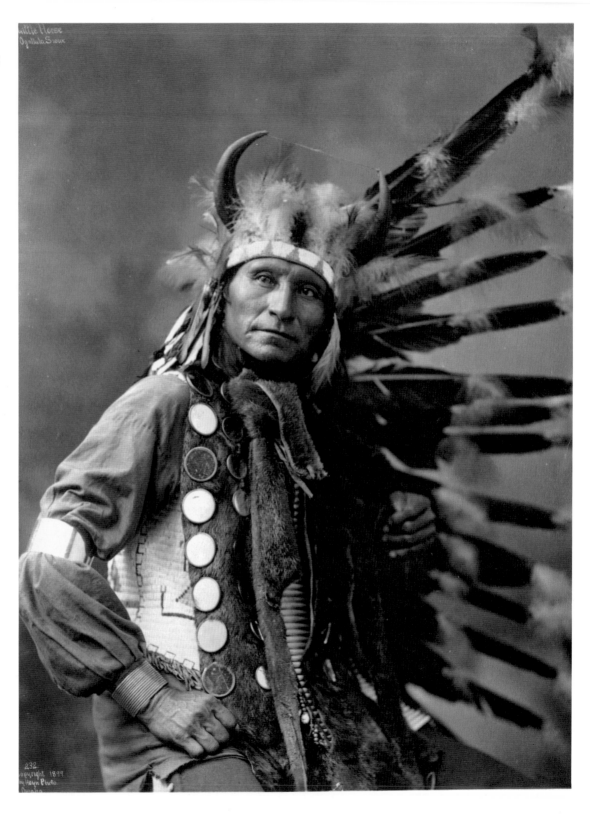

Heyn
Little Horse, Ogallula [sic] *Sioux*
1899
9½″ by 12½″

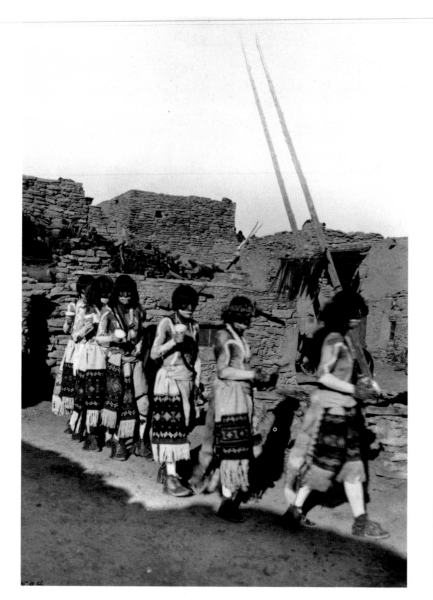

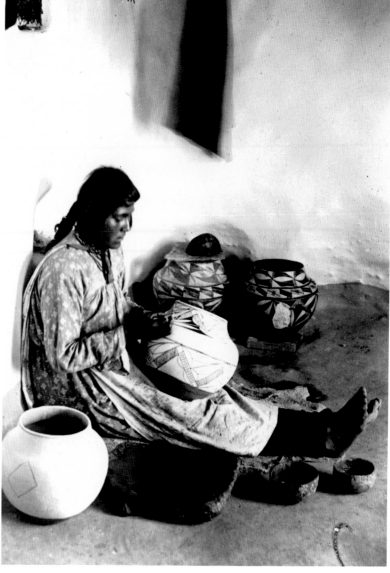

Adam Clark Vroman (1856–1916)
Hopi Snake Dance
c. 1899
platinum print
5⁷⁄₁₆″ by 7⅛″

Adam Clark Vroman (1856–1916)
Acoma, Mary Painting Pottery
1902
14½″ by 19″

(left) *A bookseller by trade, Adam Clark Vroman was part of a circle of photographers in Pasadena, California, who were fascinated by the Southwest Indians. Between 1895, when he first saw the Hopi Snake Dance, and 1904, he returned to the Southwest almost every year. "Just an amateur" is the way he once described himself. It was an overly modest assessment, for his photographs are intimate, profoundly sympathetic, and devoid of stereotype.*

(right) *When the William F. Cody Wild West Show came to New York in 1898, Gertrude Käsebier took pictures of the Sioux. An artist and photographer, she was influenced by Alfred Stieglitz and the Photo-Secession, which Stieglitz founded as part of a movement towards naturalistic photography. Käsebier is best known for her soft, subjective images, often of domestic scenes.*

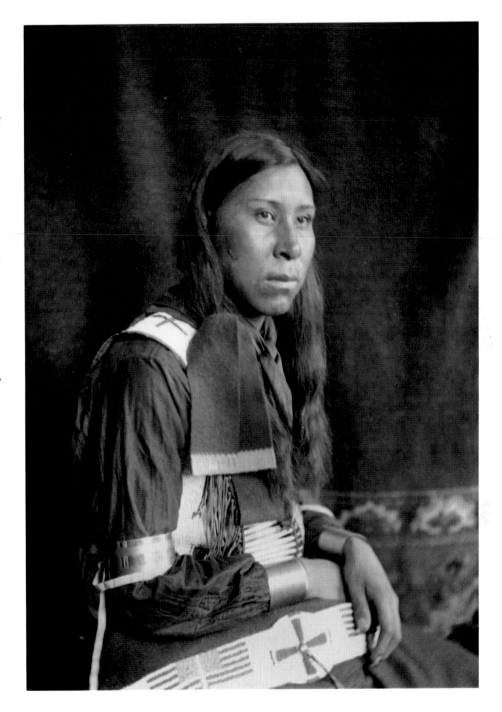

Gertrude Käsebier (1852–1934)
Samuel Lone Bear
1898
6¼" by 8"

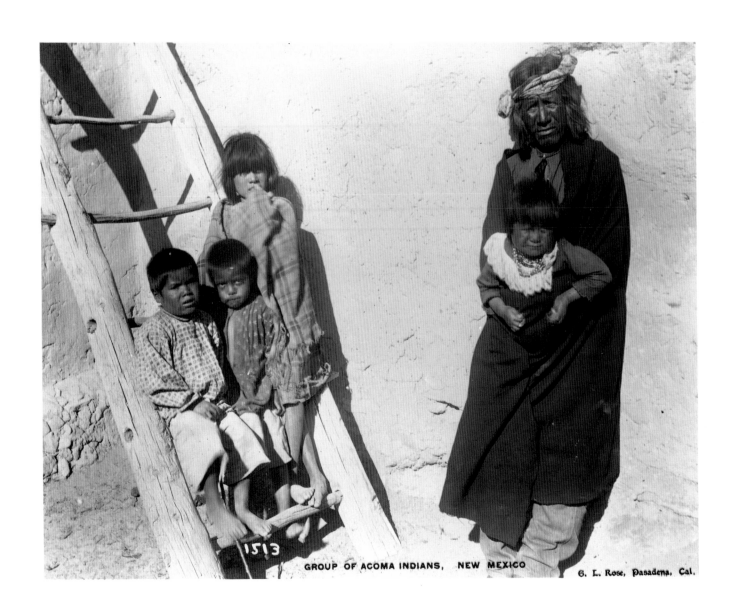

GROUP OF ACOMA INDIANS, NEW MEXICO

G. L. Rose, Pasadena, Cal.

1513

George L. Rose
Group of Acoma Indians, New Mexico
date unknown
8″ by 6″

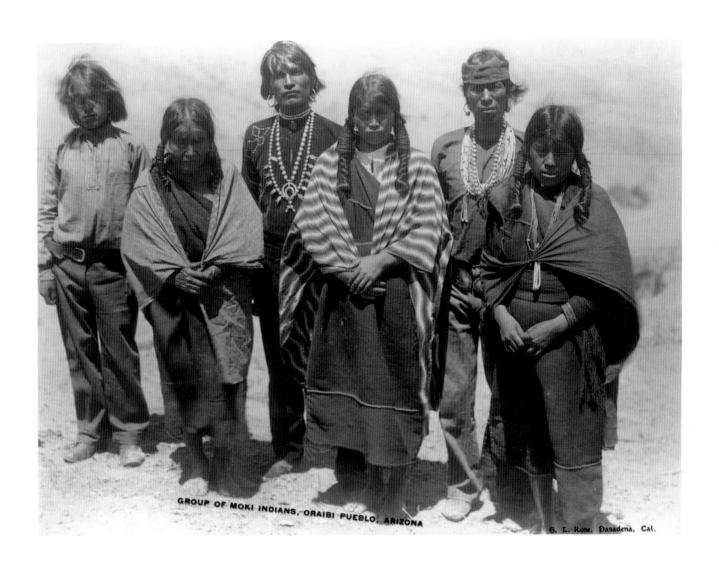

George L. Rose
Group of Moki Indians, Oraibi Pueblo,
Arizona
date unknown
8" by 6"

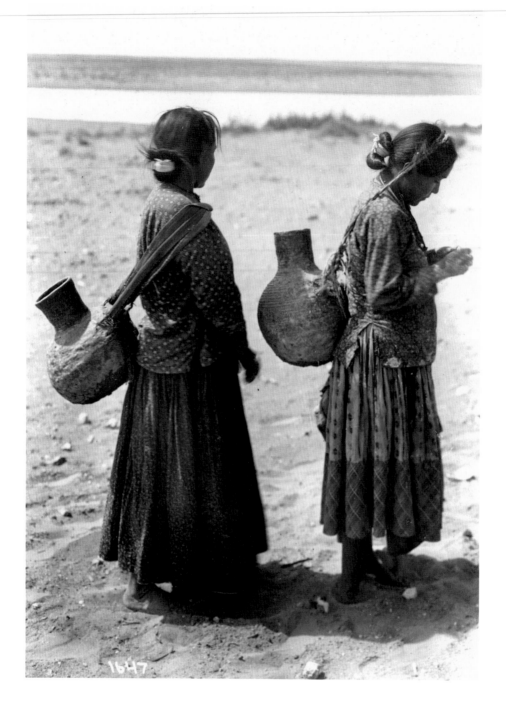

George L. Rose
Navajo Indian Women Water Carriers,
Arizona
date unknown
6" by 8"

During the 1890s and the early 1900s, Pasadena photographer George L. Rose took pictures throughout the West; the Grand Canyon, the Petrified Forest, Yosemite, Catalina Island, LaJolla, and Arizona were among the places he photographed. As a retail dealer, he sold these images in various forms including souvenir photo albums, panel views, and stereoscopic views.

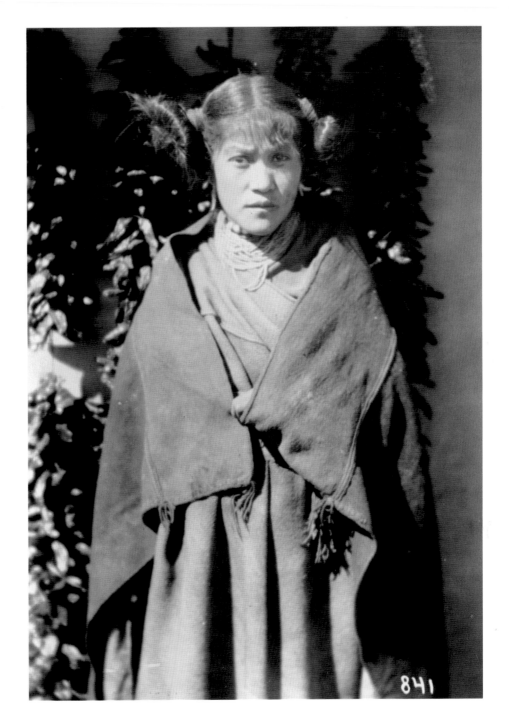

George L. Rose
Moki Indian Maiden, Oraibi Pueblo, Arizona
date unknown
6" by 8"

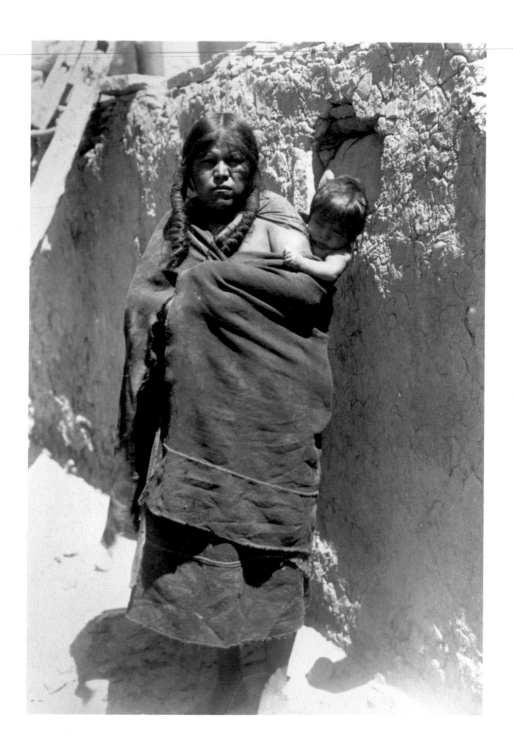

George L. Rose
Moki Indian Woman and Baby, Oraibi
Pueblo, Arizona
date unknown
6" by 8"

Born in Massachusetts, where he attended Harvard University and became friends with Theodore Roosevelt, Charles Lummis walked in 1884 from Ohio to California. After covering the Apache Wars for the Los Angeles Times, *he suffered a stroke and moved to New Mexico. He stayed with the Indians and became a crusader on their behalf, as well as a magazine editor and a poet who published many slim volumes of poetry on birch bark. As a photographer, he is admired less for his aesthetics than for his documentation and commitment to the Indians.*

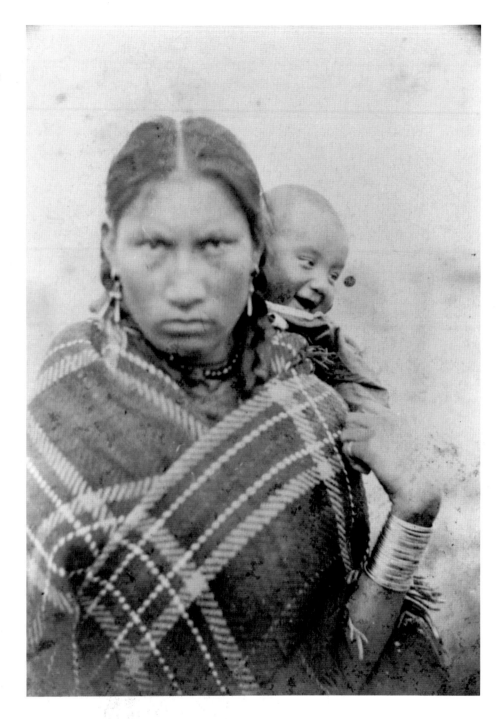

Charles Fletcher Lummis (1859–1928)
Mother and Child, Dakota
date unknown
cyanotype
4½″ by 6″

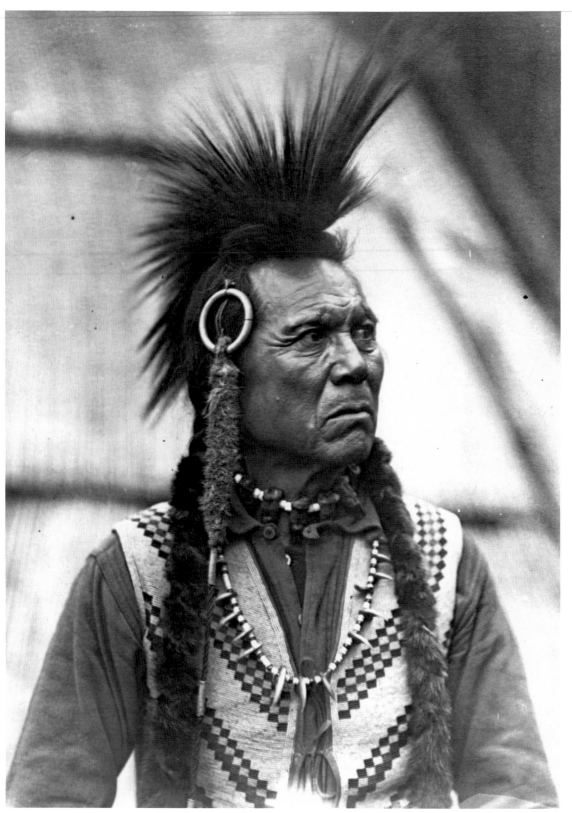

Maj. Leander Moorhouse (?–1926)
Whirlwind
date unknown
7¾″ by 9¾″

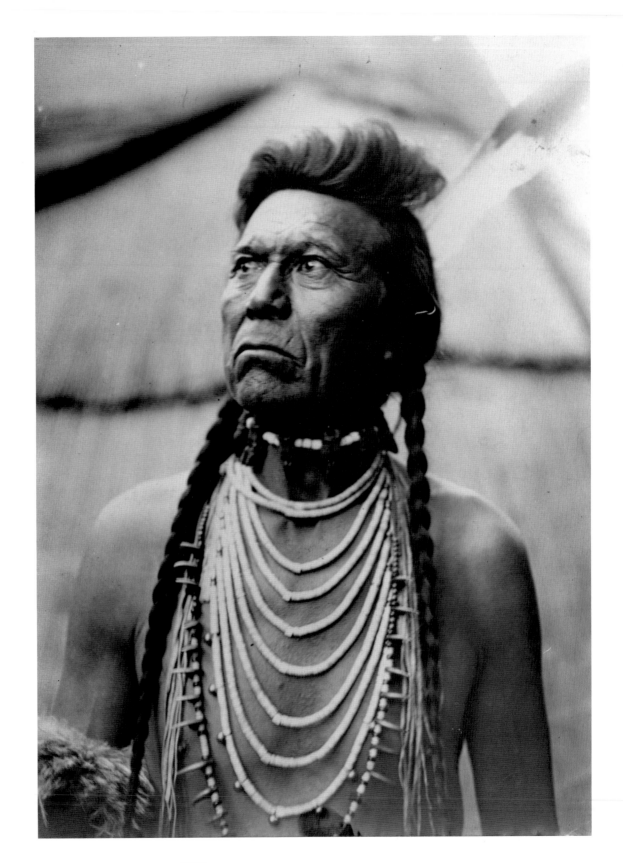

Maj. Leander Moorhouse (?–1926)
Dr. Whirlwind, Head Medicine Man
of the Tribes
date unknown
6″ by 8″

*Maj. Leander Moorhouse, the Indian agent
on the Umatilla Reservation in Oregon
around the turn of the century, photographed
the Indians in and around that area. Some of
these pictures may have been taken during
the annual Pendleton roundup, when the
Indians left the reservation and set up their
teepees in the cottonwood trees along the
banks of the Umatilla River.*

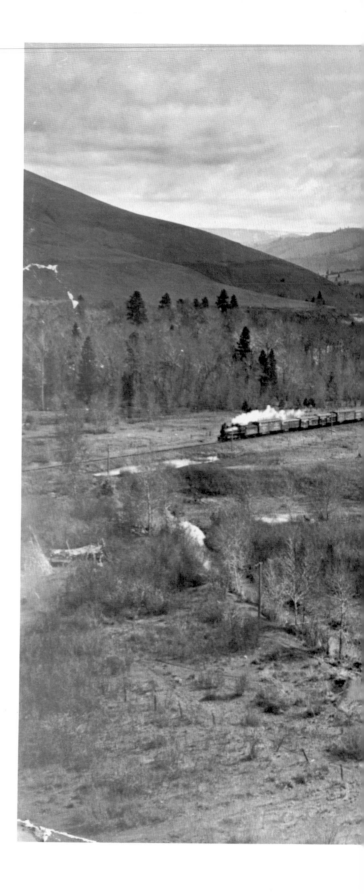

Maj. Leander Moorhouse (?–1926)
Old and New
date unknown
10" by 8"

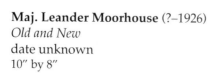

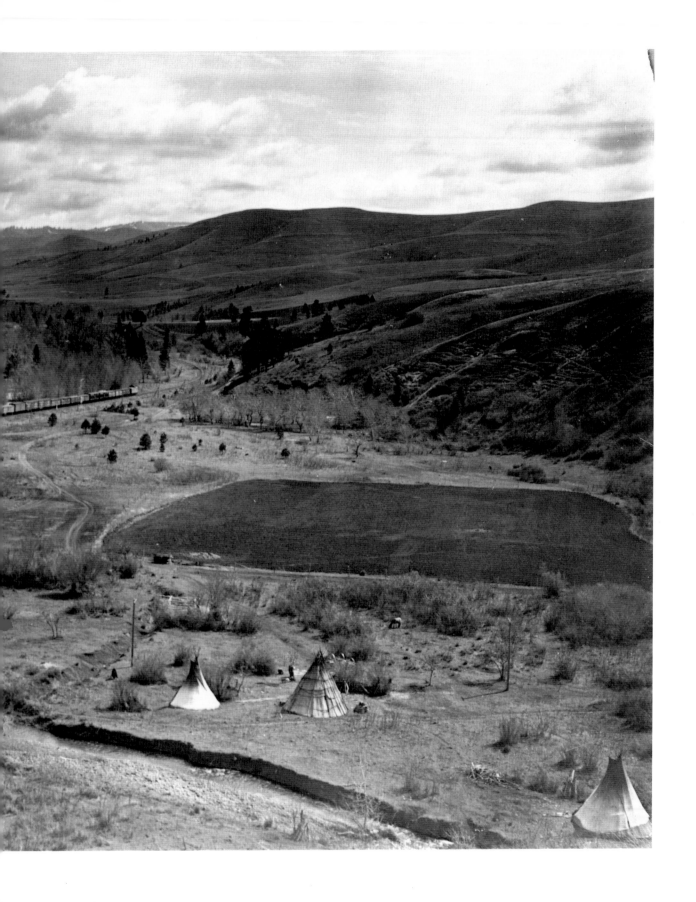

The sorrow in this old woman's face is palpable. She was around twenty when she saw Lewis and Clark. They left St. Louis in 1804, accompanied by the sixteen-year-old Shoshoni girl Sacajawea, who eased their way with the Indians.

Maj. Leander Moorhouse (?–1926)
Petowya, the 115-Year-Old Woman Who Saw Lewis and Clark in 1806
1901
silver gelatin
5¹⁵⁄₁₆″ by 7¹⁵⁄₁₆″

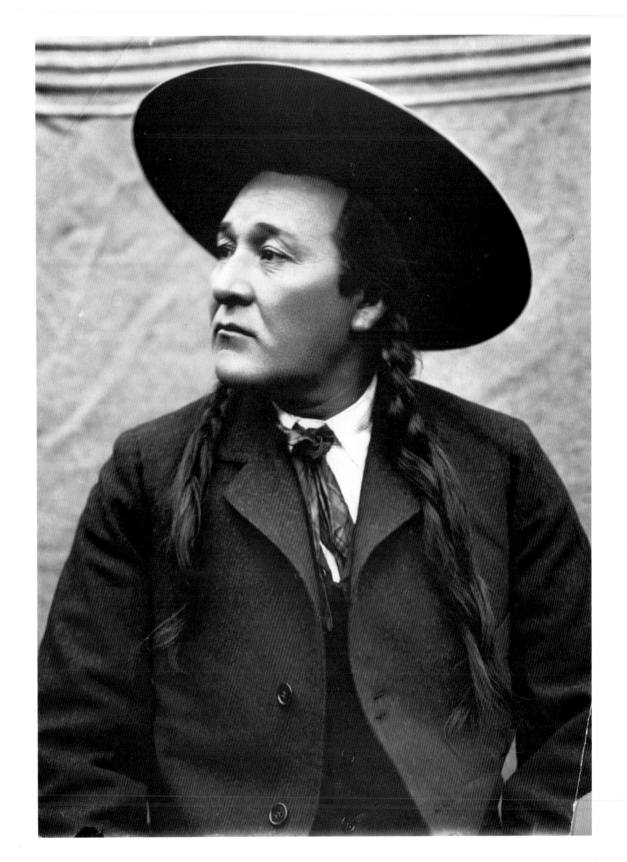

Maj. Leander Moorhouse (?–1926)
Descendant of Alex McKay
date unknown
8″ by 10″

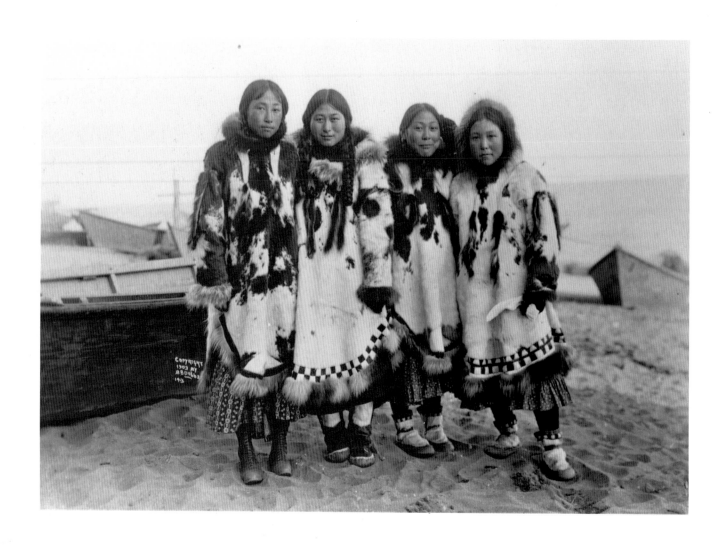

Beverly B. Dobbs (1868–?)
Untitled
1903
9½″ by 7¾″

Beverly Dobbs was a farmer's son who learned photography in Lincoln, Nebraska. For twelve years, he operated a gallery in Bellingham, Washington. In 1900, lured by the promise of gold, he moved to Nome, Alaska, where he photographed the Eskimos and the Seward Peninsula. His greatest moment of recognition came in 1904, when he was awarded a gold medal at the Louisiana Purchase Exposition for his Eskimo portraits.

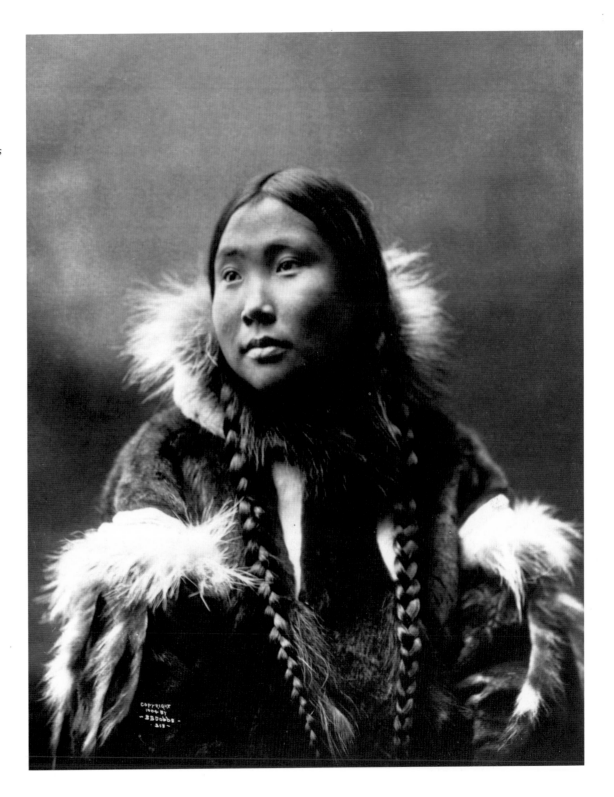

Beverly B. Dobbs (1868–?)
Untitled
1904
7½″ by 9½″

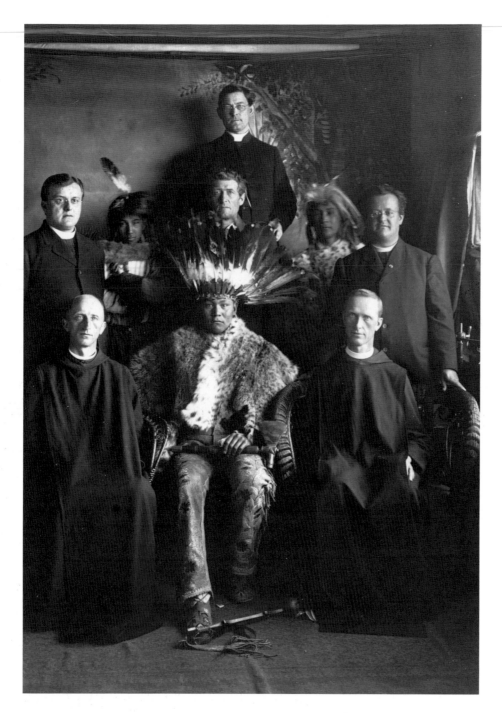

This undated photograph by Frank B. Fiske touches on a topic that seldom appears in photographs of Native Americans: the massive influence of Christian missionaries of various denominations, who for many years maintained a great interest in converting "the pagan." This print was made from an original plate.

Frank B. Fiske
Untitled
date unknown
6⅛″ by 8⅛″

Although Frank Fiske and Edward S. Curtis may never have met, they were both at Standing Rock in 1905, when this picture was taken. Like Curtis, Fiske often used dramatic lighting. Unlike Curtis, he preferred sharp focus. Although Fiske was born on a military post and grew up among the Sioux, his stance towards the Indians was typical of the white attitude of the day; while not entirely unsympathetic, he supported the military actions taken against them.

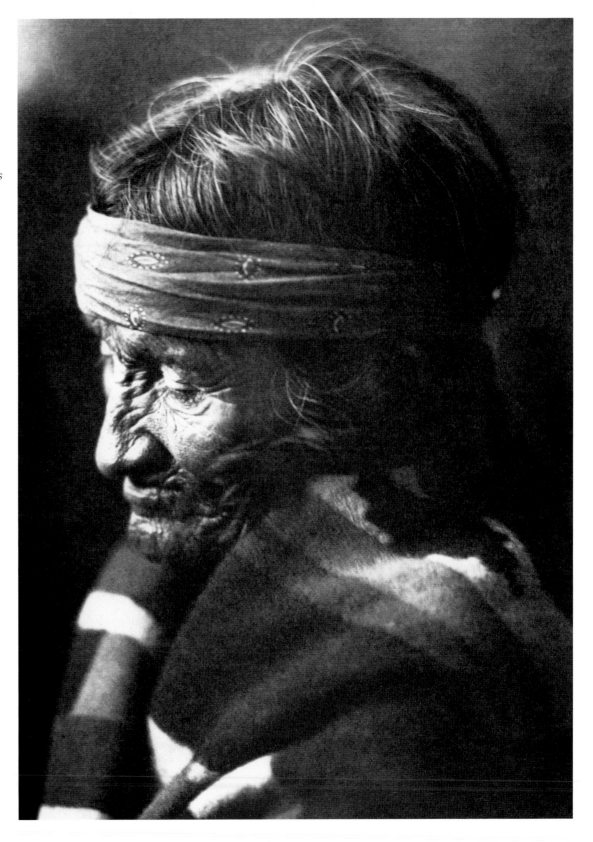

Frank B. Fiske (1883–1952)
Cosey, Sioux
1905
toned gelatin print
3³/₄″ by 5¹/₂″

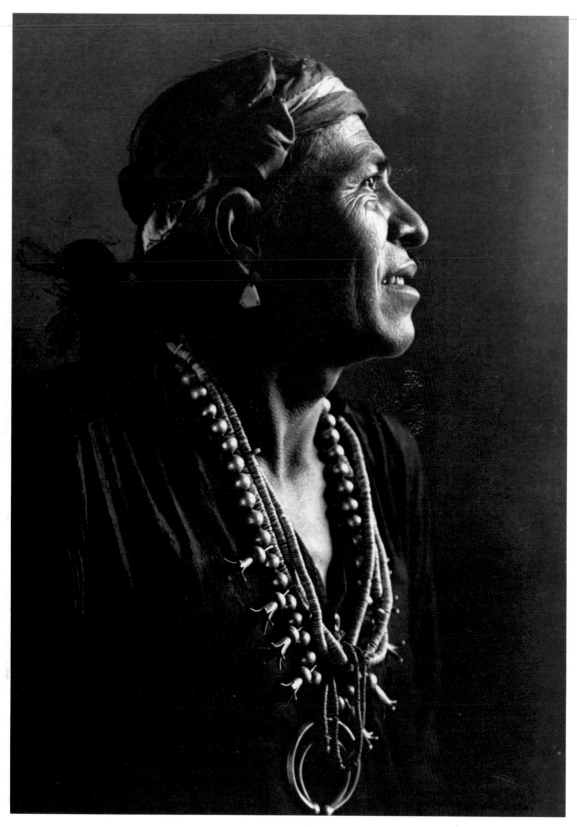

Carl Moon (1879–1948)
Mequecito
1904
7¼″ by 9¾″

Carl Moon moved to Albuquerque, New Mexico, in 1903 and began photographing the Southwest Indians. Like Curtis, whom he is accused of imitating, Moon posed his pictures for maximum sentimental appeal. He was fond of soft-focus, vignetting, cropping, retouching, and drawing on the finished print. A vastly popular photographer in his lifetime, he was also an artist and an illustrator, often for books written by his wife. His last book, published posthumously, was a collaboration with her entitled One Little Indian.

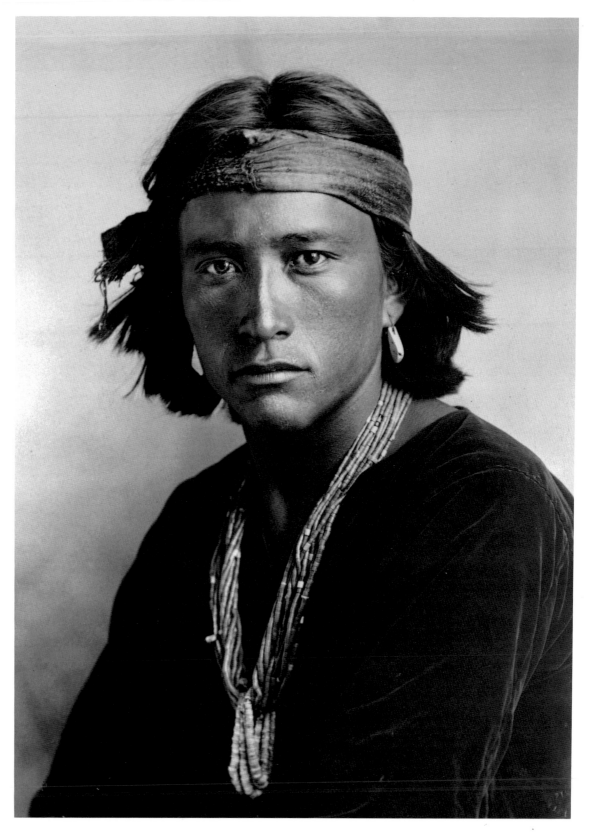

Carl Moon (1879–1948)
Navajo Boy
c. 1905
silver print
9½″ by 11¼″

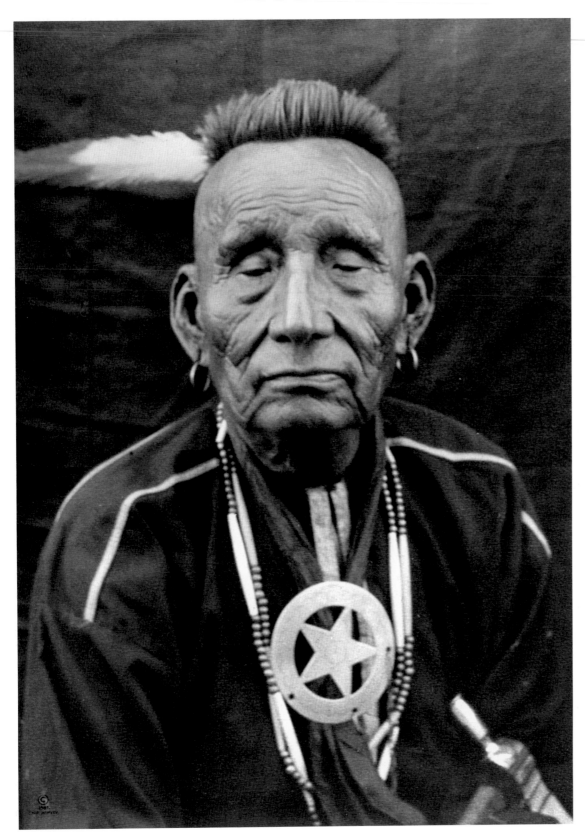

Carl Moon (1879–1948)
Bear Legs, Osage
1902
silver print
12″ by 16″

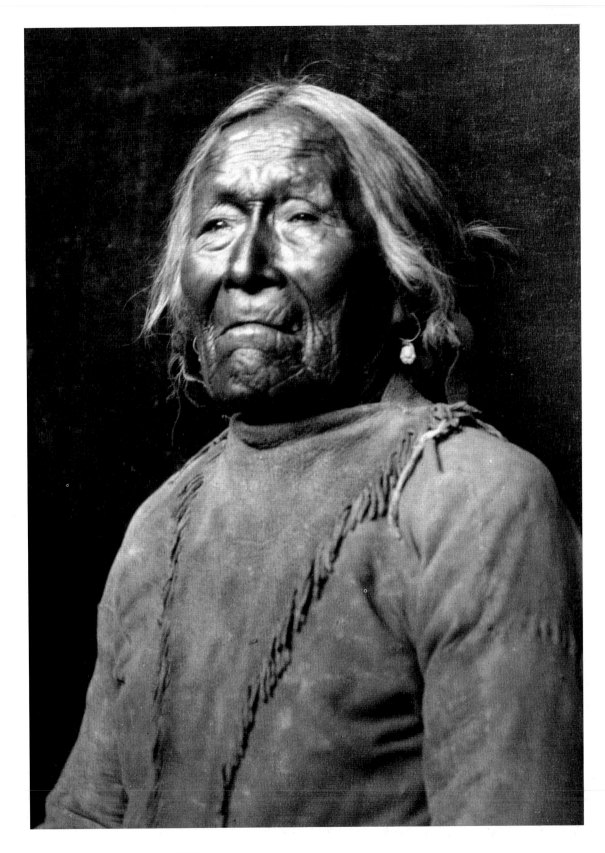

Carl Moon (1879–1948)
Old Apache Scout
1909
silver print
12½″ by 16¼″

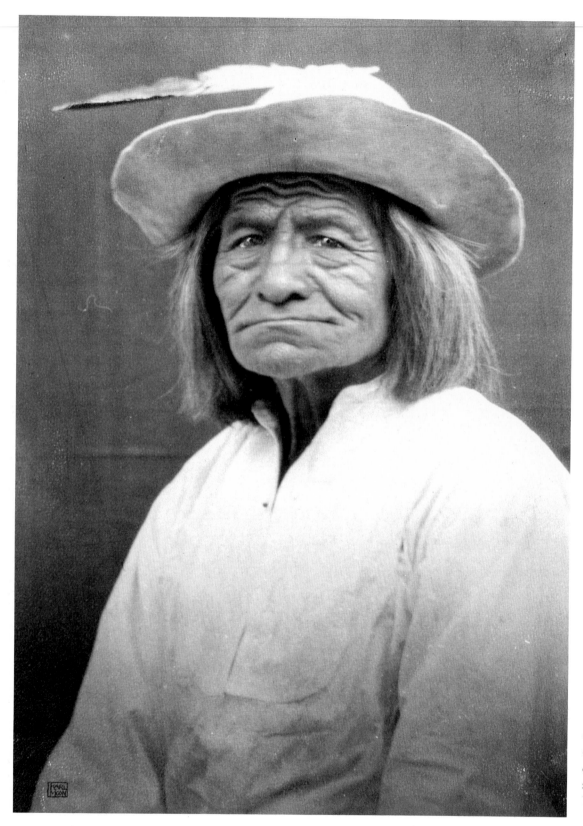

Carl Moon (1879–1948)
Captain Bill Burro, Havasupi
c. 1910
silver print
12" by 16"

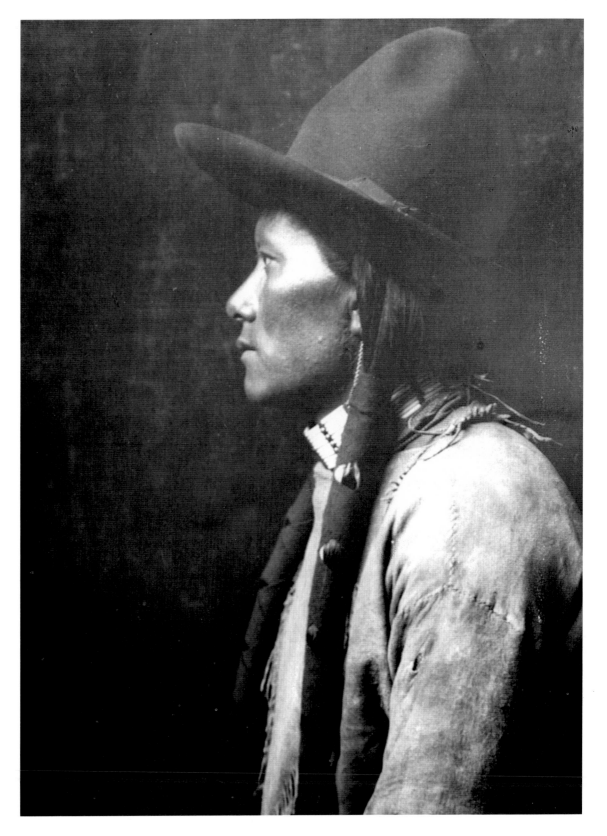

Carl Moon (1879–1948)
Coutudle
1909
silver print
12″ by 16″

Carl Moon (1879–1948)
Storyteller
1914
silver bromide (?)
16⁹⁄₁₆″ by 12¹⁵⁄₁₆″

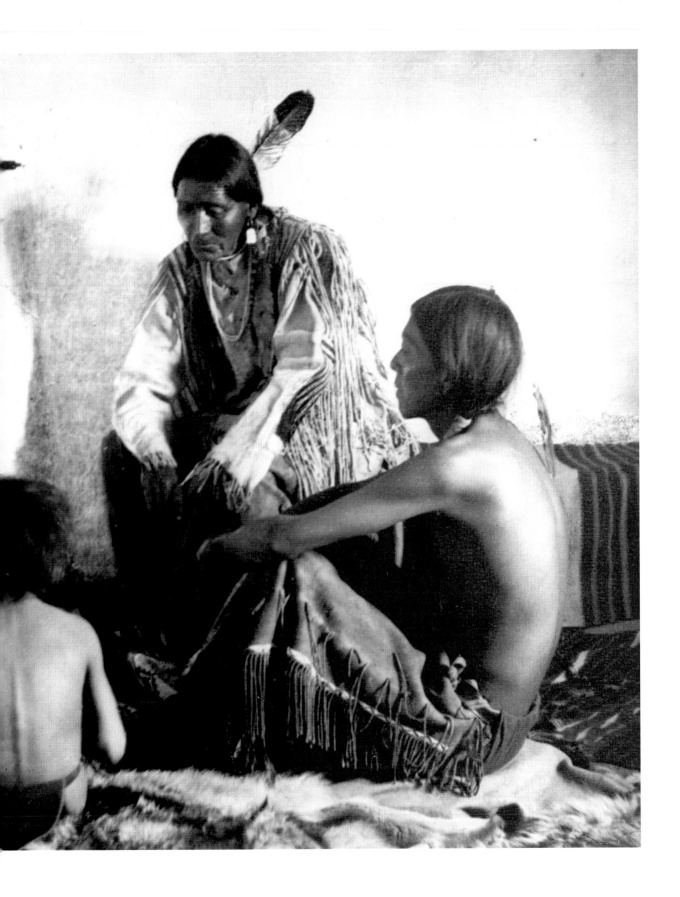

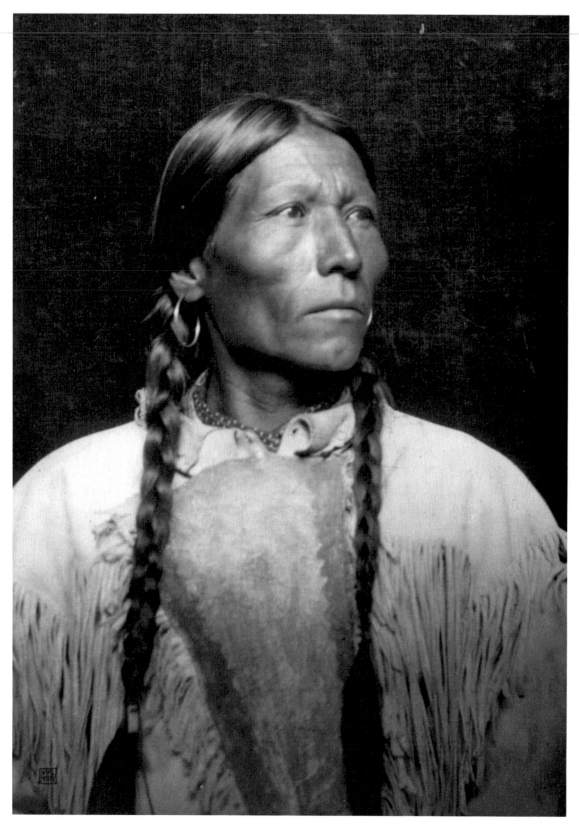

Carl Moon (1879–1948)
Unidentified Portrait
1910
silver print
12″ by 16½″

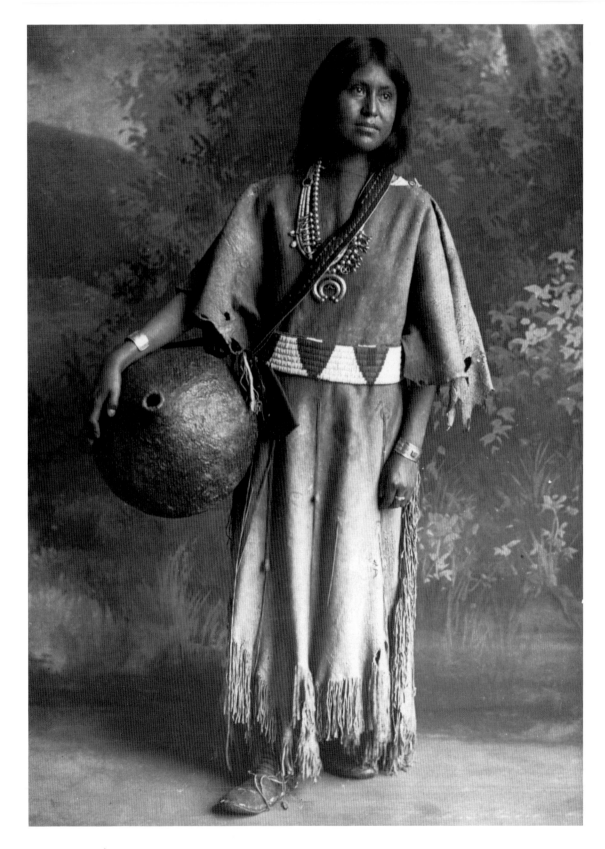

Carl Moon (1879–1948)
Isleta Indian Woman
1905
8⅞″ by 13⅜″

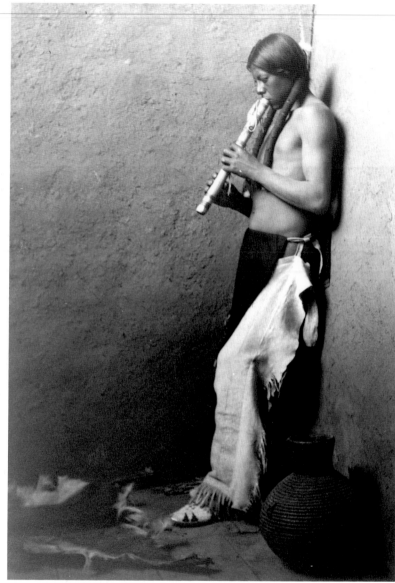

Carl Moon (1879–1948)
Navajo Silversmith
1909
silver print
13″ by 17″

Carl Moon (1879–1948)
Before the Dance: A Taos Indian Practicing the Corn Song
1909
silver print
11¼″ by 16¼″

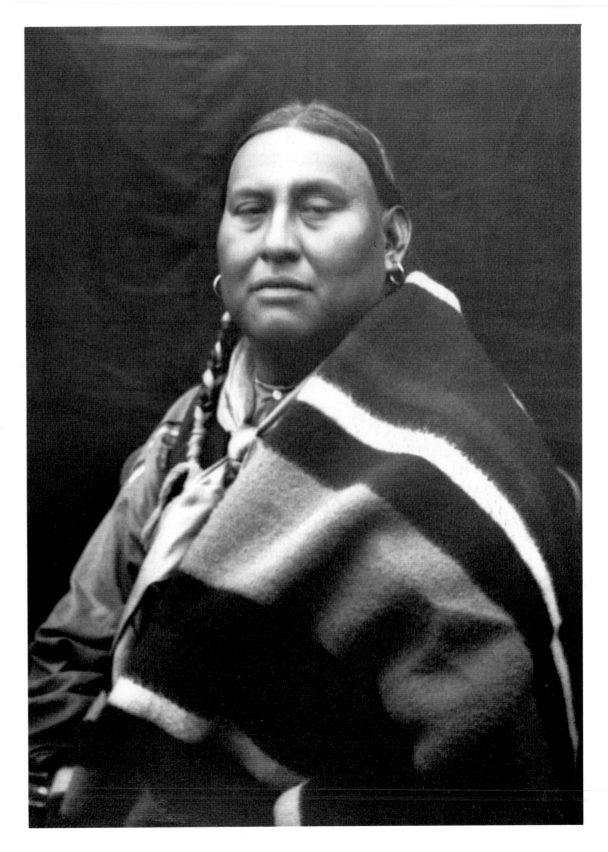

Carl Moon (1879–1948)
Orsh-O-Ba, Osage
1912
11¾″ by 16½″

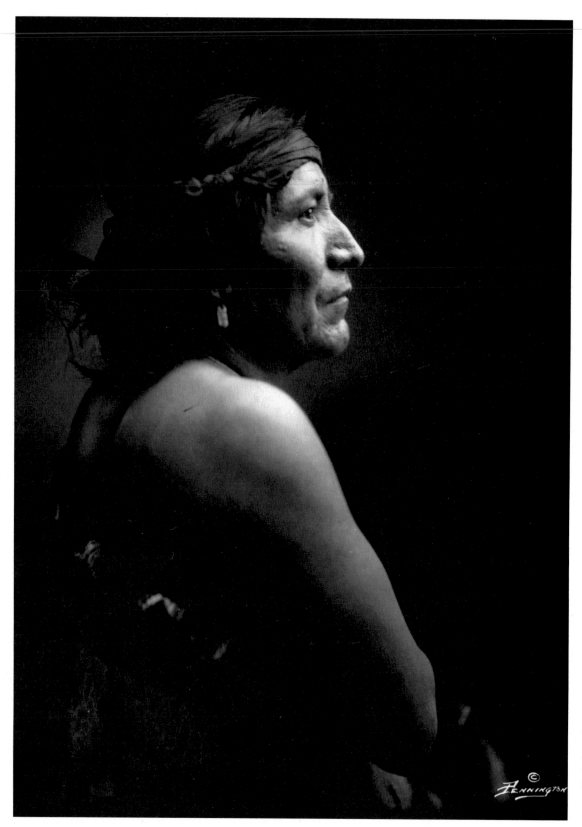

William Marion Pennington (1874–1937)
Navajo Portrait
date unknown
8″ by 10″

Afflicted with consumption, William Marion Pennington sought the arid climate of the Southwest and came to Albuquerque in 1904, where he established a photographic studio and a movie theater. In 1908 he moved to Durango, Colorado. From there, he and his partner, L. C. Updike, frequently traveled with a six-horse wagon to the Navajo reservation, where they stayed as long as three months. His portraits, often taken with a wide-open lens, have been called "Rembrandtesque."

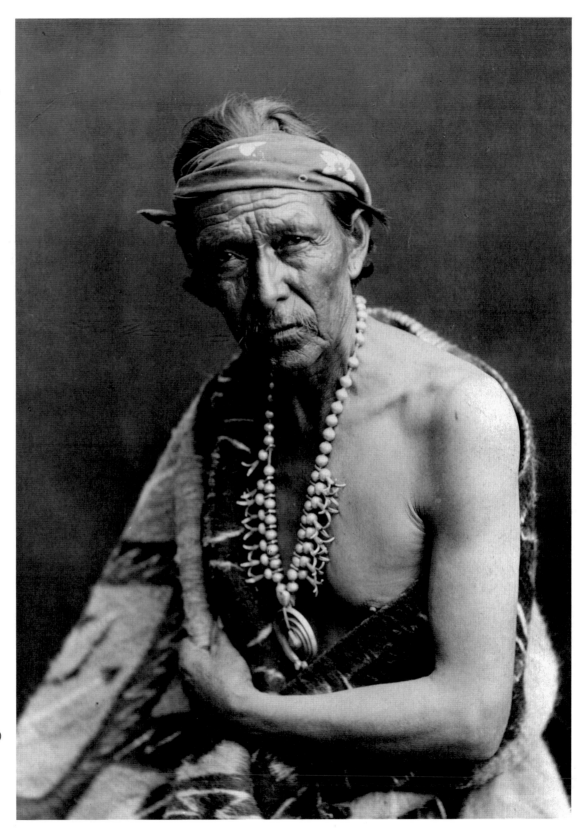

William Marion Pennington (1874–1937)
Untitled
date unknown
8" by 10"

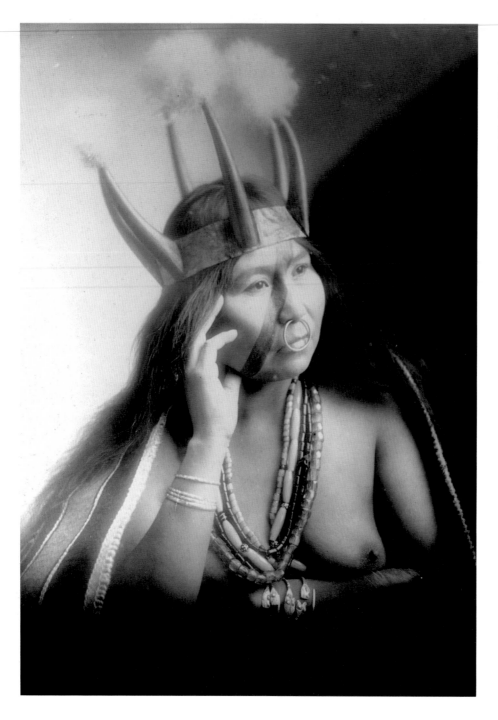

Among the Tlinget Indians of Alaska, it was common for women to pierce the septum of the nose in order to wear ornaments such as the one in this picture. The Tlinget were also partial to headdresses of various kinds decorated with ermine streamers.

Harriet Smith Pullen (1860–1947)
Mrs. Stene-Tu, a Tlinget Belle
1906
silver print
13″ by 16¼″

A widow with four children, Harriet Smith Pullen came to Skagway, Alaska, in the gold rush of 1897. She lugged a stove to the beach, baked apple pies, and sold them to prospectors. Within three years, she opened a restaurant, drove a team of four horses carrying freight across a forbidding landscape, and established a small hotel. Later, she added a museum to the hotel and exhibited a large collection of Alaskan objects. Whether she was the photographer or the curator of the picture is uncertain.

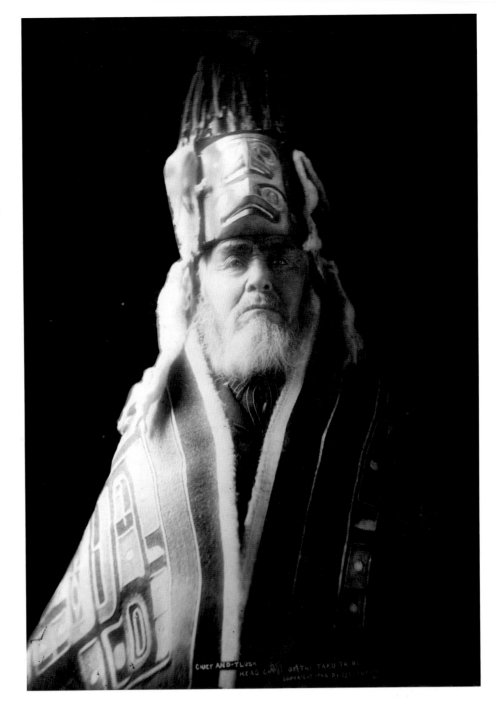

Harriet Smith Pullen (1860–1947)
Chief Ano-Ylosk,
Head Chief of the Taku Tribe
1906
14″ by 16⅞″

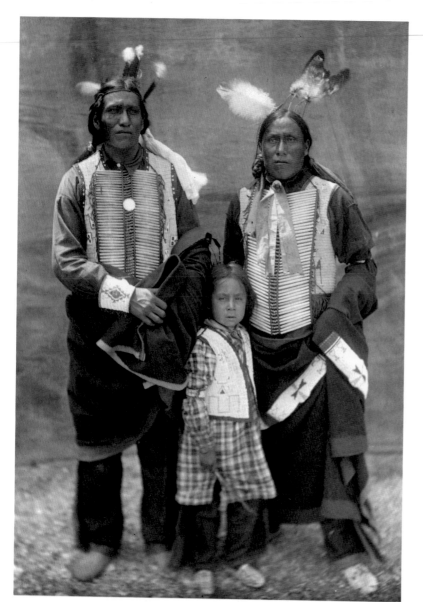

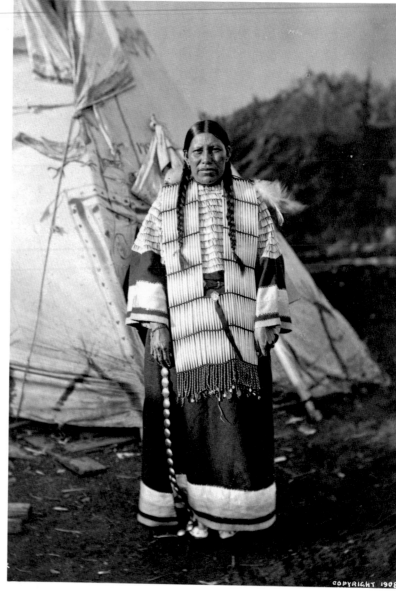

J. A. Johnson
Untitled
date unknown
7¹⁄₂″ by 9¹⁄₂″

J. A. Johnson
Mrs. Black Hawk, Sioux
1908
silver print
7¹⁄₄″ by 9″

Although nothing is known about J. A. Johnson's life, his photography shows a stylistic ambivalence characteristic of the era. The traditional clothing and teepee in the picture of Mrs. Black Hawk and the dramatic lighting of the portrait of Spotted Elk indicate the influence of Pictorialism. But in the other pictures, it is impossible to ignore the sad transition that had taken place in the Indians' lives.

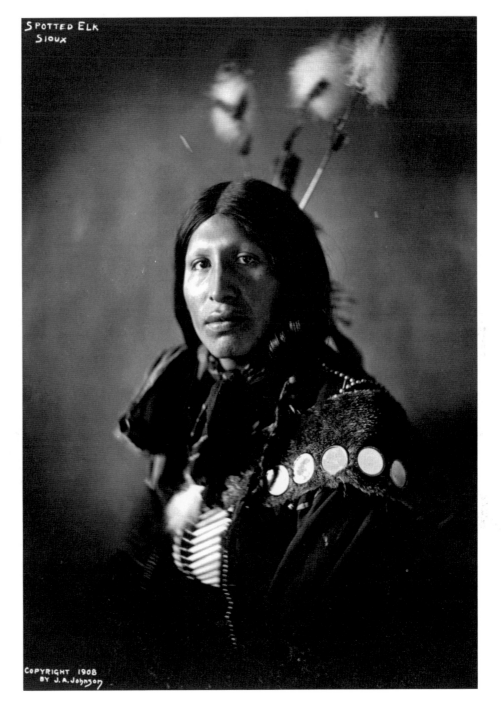

J. A. Johnson
Spotted Elk, Sioux
1908
7½″ by 9½″

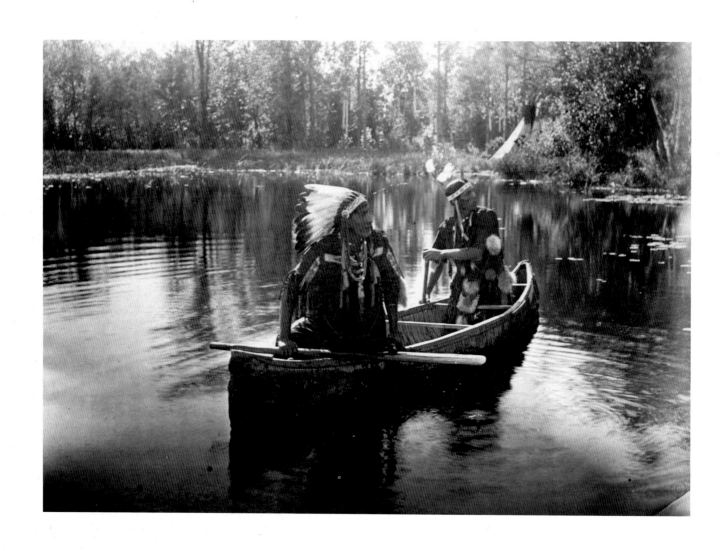

Roland Reed (1864–1934)
Untitled
8¼″ by 6⅛″

Although these photographs are untitled,
Reed customarily used highly evocative titles.
A photograph very similar to this one, for
example, was called Prayer to the
Thunderbird.

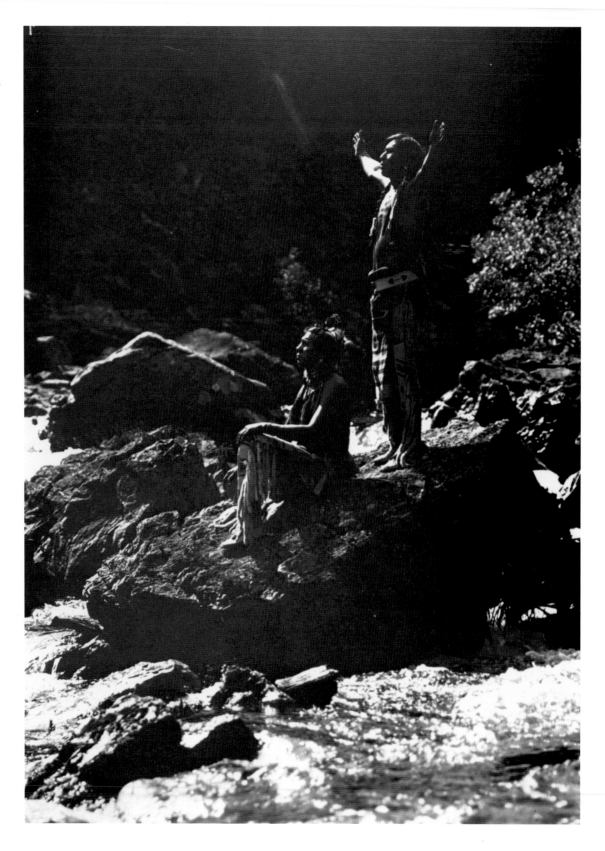

Roland Reed (1864–1934)
Untitled
15½″ by 19¾″

When Roland Reed was seven years old, a group of Menomini Indians saved two boys from drowning near his home in Wisconsin. "I knew these Indians well, especially one called Thundercloud who…became the hero of my boyhood days," he wrote. "This incident stimulated in me a regard for the Indians which has grown with the years." His pictures are melodramatic, highly romantic, and self-consciously posed. Nonetheless, critics writing in 1915 lauded his realism.

Roland Reed (1864–1934)
CusterBattlefield
1910
14" by 8"

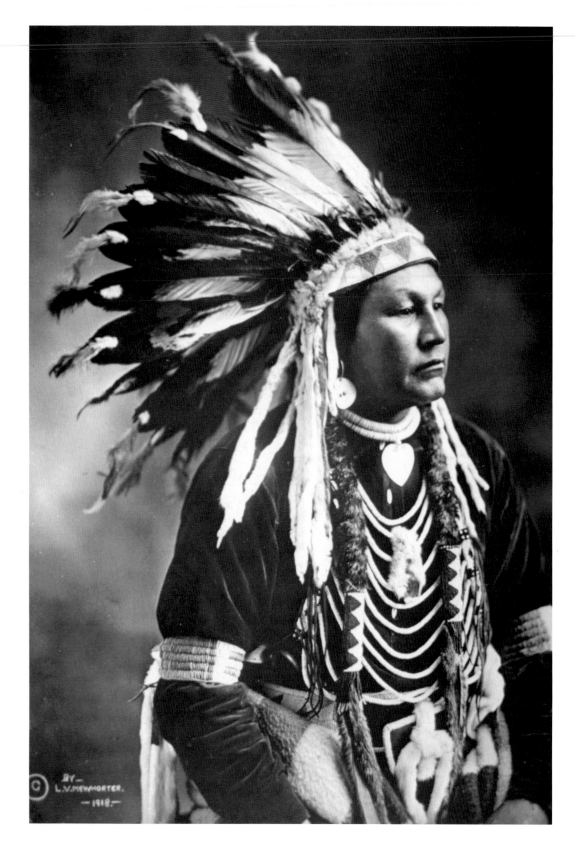

Little known as a photographer, Lucullus McWhorter was a native of West Virginia who came to Washington State in 1903 to homestead. In 1914, he met Mourning Dove, an Okanogan woman who wanted to write novels. McWhorter helped her to publish fiction and to record the folktales of her people. McWhorter was the founder of American Archaeologist *and the author of, among other works,* Yellow Wolf, The Crime Against the Yakimas, *and* Hear Me, My Chiefs!

Lucullus V. McWhorter
Untitled
1918
22¾" by 32¾"

This curiously affecting image of a middle-aged Indian was taken by a little-known photographer from Brockton, Massachusetts.

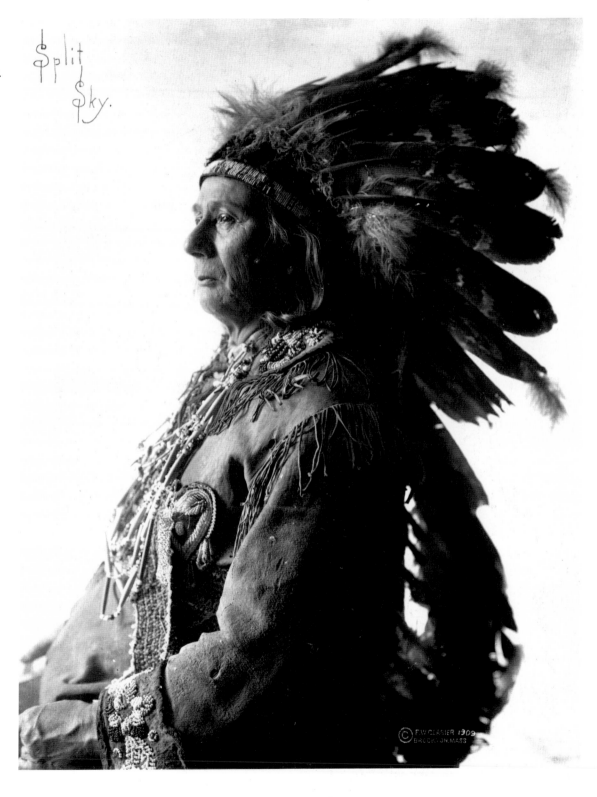

F. W. Glaser
Split Sky
1909
7½″ by 9½″

Index to Photographers

Title page: Carpenter, *The Messenger,*
 undated, 9½" by 7¾"

Bibliography

Berkhofer, Robert F., Jr. *The White Man's Indian: Images of the American Indian From Columbus to the Present.* New York: Vintage Books, Random House, 1979.

Blackman, Margaret B. "Posing the American Indian." *Natural History,* vol. 89, no. 10 (October 1980): 68–75.

Brown, Dee. *Bury My Heart at Wounded Knee.* New York: Washington Square Press, 1970.

Carl Moon: Photographer and Illustrator of the American Southwest. Catalogue 83: A Selection of Vintage Photographs, Original Art and Related Material. San Francisco: Argonaut Book Shop, 1982.

Current, Karen. *Photography and the Old West.* Photographs selected and printed by William R. Current. New York: Abradale Press, Harry N. Abrams, Inc., in association with the Amon Carter Museum of Western Art, 1978.

Fleming, Paula Richardson, and Luskey, Judith. *The North American Indians in Early Photographs.* New York: Dorset Press, 1986.

Hoobler, Dorothy and Thomas. *Photographing the Frontier.* New York: G. P. Putnam's Sons, 1980.

Johnston, Patricia Condon. "The Indian Photographs of Roland Reed." *The American West,* vol. XV, no. 2 (March/April 1978): 44–57.

North American Portraits from the Collection of Kurt Koegler. Milwaukee Art Museum, May 20–Sept. 18, 1983. Milwaukee: Milwaukee Art Museum, 1983.

Packard, Gar and Maggy. *Southwest 1880 with Ben Wittick, Pioneer Photographer of Indian and Frontier Life.* Photographs from the Museum of New Mexico Collection. Santa Fe: Packard Publications, 1970.

Shadowy Evidence: The Photography of Edward S. Curtis and His Contemporaries. Seattle Art Museum, Aug. 10–Nov. 19, 1989. Seattle: Seattle Art Museum, 1989.

Taft, Robert. *Photography and the American Scene: A Social History, 1839–1889.* New York: Dover Publications, 1938.

Trenton, Patricia, and Houlihan, Patrick T. *Native Americans: Five Centuries of Changing Images.* New York: Harry N. Abrams, Inc. 1989.

Webb, William, and Weinstein, Robert A. *Dwellers at the Source: Southwestern Indian Photographs by A. C. Vroman, 1895–1904.* Albuquerque: University of New Mexico Press, 1973.

Welling, William. *Photography in America: The Formative Years, 1839–1900.* Albuquerque: University of New Mexico Press, 1978.